W9-AJW-533

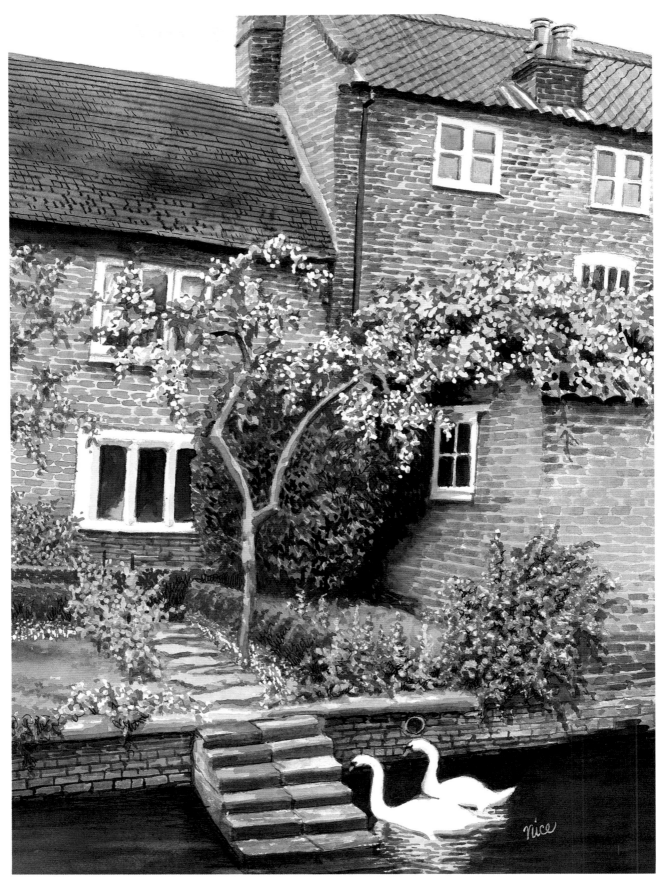

THE HIDDEN GARDEN
8" x 10" (20cm x 25cm) Watercolor with pen-and-ink accents

Painting
Country
gardens

in watercolor, pen & ink

Claudia Nice

NORTH LIGHT BOOKS
CINCINNATI, OHIO
www.artistsnetwork.com

About the Author

Claudia Nice is a native of the Pacific Northwest and a self-taught artist who developed her realistic art style by sketching from nature. She is a multimedia artist, but prefers pen and ink and watercolor when working in the field. Claudia has been an art consultant and instructor for Koh-I-Noor/Rapidograph and Grumbacher. She is also a certified teacher in the Winsor & Newton Col Art organization and represents the United States as a member of the Advisory Panel for The Society of all Artists in Great Britain.

She travels internationally conducting workshops, seminars and demonstrations at schools, clubs, shops and trade shows. Claudia recently opened her own teaching studio, Brightwood Studio (www.bright woodstudio.com), in the beautiful Cascade wilderness near Mt. Hood, Oregon. Her oils, watercolors, and ink drawings can be found in private collections across the continent and internationally.

Claudia has authored sixteen successful art instruction books, including *Sketching Your Favorite Subjects in Pen & Ink; Creating Textures In Pen & Ink With Watercolor; Painting Nature in Pen & Ink With Watercolor; Painting Weathered Buildings in Pen, Ink & Watercolor;* and *How to Keep a Sketchbook Journal,* all of which were featured in the North Light Book Club.

When not involved with her art career, Claudia enjoys gardening, hiking and horseback riding in the wilderness behind her home on Mt. Hood. Using her artistic eye to spot details, Claudia has developed her skills as a man-tracker and is involved, along with her husband, Jim, as a Search and Rescue volunteer.

Painting Country Gardens in Watercolor, Pen & Ink. Copyright © 2002 by Claudia Nice. Manufactured in China. All rights reserved. No part of this book may be reproduced in any form or by any electronic or mechanical means including information storage and retrieval systems without permission in writing from the publisher, except by a reviewer, who may quote brief passages in a review. Published by North Light Books, an imprint of F&W Publications, Inc., 4700 East Galbraith Road, Cincinnati, Ohio 45236. (800) 289-0963. First edition.

Other fine North Light Books are available from your local bookstore, art supply store or direct from the publisher.

06 05 04 03 02 5 4 3 2 1

Library of Congress Cataloging-in-Publication Data

Nice, Claudia
 Painting country gardens in watercolor, pen & ink /
Claudia Nice.
 p. cm.
 ISBN 1-58180-142-4 (alk. paper)
 1. Watercolor painting—Technique. 2. Pen drawing—
Technique. 3. Gardens in art. I. Title.

ND2420 .N497 2002
751.42'2346—dc21 2001052150

Editor: Christine Doyle
Production Coordinator: Kristen Heller
Designer: Joanna Detz
Production Artist: Cheryl VanDeMotter

Illustrations on pages 5, 56, 81 and 111 © Susan Scheewe Publications. Reprinted with permission.

Metric Conversion Chart

TO CONVERT	TO	MULTIPLY BY
Inches	Centimeters	2.54
Centimeters	Inches	0.4
Feet	Centimeters	30.5
Centimeters	Feet	0.03
Yards	Meters	0.9
Meters	Yards	1.1
Sq. Inches	Sq. Centimeters	6.45
Sq. Centimeters	Sq. Inches	0.16
Sq. Feet	Sq. Meters	0.09
Sq. Meters	Sq. Feet	10.8
Sq. Yards	Sq. Meters	0.8
Sq. Meters	Sq. Yards	1.2
Pounds	Kilograms	0.45
Kilograms	Pounds	2.2
Ounces	Grams	28.4
Grams	Ounces	0.04

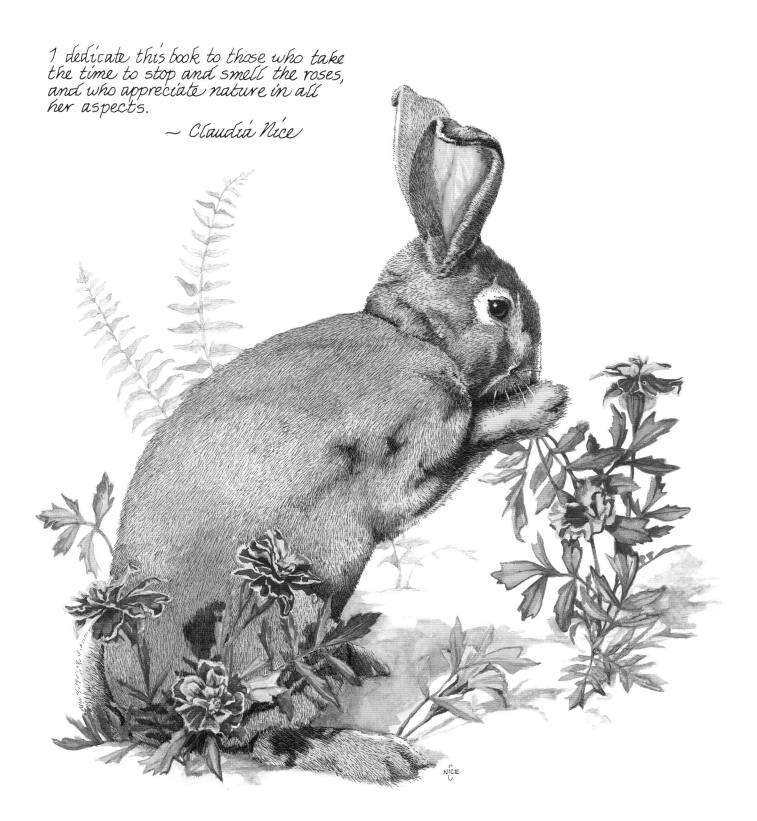

I dedicate this book to those who take the time to stop and smell the roses, and who appreciate nature in all her aspects.

~ Claudia Nice

THUMPER IN THE MARIGOLDS
8" x 10" (20cm x 25cm) Pen and ink, watercolor

© Susan Scheewe Publications

Table of Contents

Introduction

The flower garden has always been one of my favorite places. There the grand scheme of life is played out on a scale I can handle. In the flower garden, birth, growth, the joy of success and the bittersweet taste of death are all experienced in a yearly cycle. There is serenity and beauty among the flowers. Like old friends, they urge me to linger, and when I do, the petty cares of everyday life seem to melt away. Each floral face, creeping creature and lilting birdsong is a reminder of life's deeper meaning. The labor I do in the garden, be it planting, weeding or sketching, is a work of love. My people have all been gardeners. My mother and grandmother taught me a reverence for growing things. I can't see an old trowel or finger-worn garden glove without thinking of them. It's called nostalgia, and I love it. I perpetuate nostalgia by placing old rusty relics about my garden. Washtubs, calf nursing buckets, chicken waterers, and even an old potbellied stove have been recycled as outdoor planters. My gardens are old fashioned, spontaneous, and just a touch on the wild side, like all the gardens I learned to love as a child. I pass on these memories and what knowledge I have acquired in the depicting of florals, to you, my readers. May this book spark a few personal memories and inspire you to pick up your pen and brush, and paint your own old-fashioned garden.

Best wishes,

Claudia Nice

Materials and Techniques

Good tools and art supplies are essential for producing your best work. Struggling with a bad brush on cheap, poor-quality paper can take the enjoyment right out of painting. It's better to have a few good-quality supplies than a bucket full of inferior implements. This section is intended to help you get better acquainted with the materials used for pen-and-ink and watercolor work in order for you to choose wisely at the art store.

Paper

Paper used for pen-and-ink work should be polished enough to allow the pen to glide over its surface without snagging, picking up lint or clogging. The resulting ink lines should appear crisp.

Watercolor paper needs to have a nice balance between absorbency and sizing. (Sizing controls the spread and absorption of paint, allowing crisp edges and smooth washes.) Cheap student-grade paper tends to either warp into hills and valleys when water washes are applied, or be so nonabsorbent that it repels the paint. I used Fabriano Uno (Savoir Faire) 140-lb. (300 gsm) cold-press watercolor paper for most of the paintings in this book. Winsor & Newton Artists' Water Colour Paper and Arches are good alternatives.

Paper Preparation

Taping the edges of the paper to a board while painting will lessen warping and help the paper return to its original shape when dry. Wetting the paper and stroking the water back and forth with a flat brush will help redistribute the sizing evenly, allowing for washes with a unified consistency. Let the paper dry completely before beginning your project.

Pen

The ideal pen has a steady leak-free flow and a precise nib that can be stroked in all directions. This book was illustrated using Koh-I-Noor Rapidograph pens. Each pen consists of a hollow nib, a self-contained changeable ink supply and a plastic holder. Within the hollow nib is a delicate wire and weight that shifts back and forth during use, bringing the ink forward. The Rapidograph comes in a variety of sizes. I most often use the 0.25mm nib in my work. In this book, I have used the 0.25mm nib unless otherwise noted. Drawbacks: Cost and maintenance. Like any instrument, the Rapidograph pen requires proper care and cleaning.

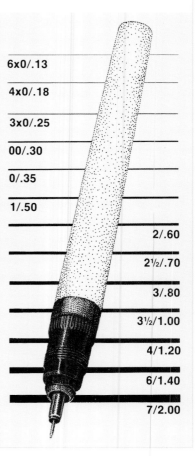

6x0/.13
4x0/.18
3x0/.25
00/.30
0/.35
1/.50
2/.60
2½/.70
3/.80
3½/1.00
4/1.20
6/1.40
7/2.00

Brushes I use most often —

Aquarelles ¾" & ½"

Flats —
⅛" & ¼"

Round brushes no. 4 & 6

KOLINSKY

Larger "wash" brush

A more economical and maintenance-free version of the technical pen is the disposable Artist Pen by Grumbacher. It comes prefilled with a quality, brush-proof ink. A range of colors is available. The Artist Pen is similar in usage to the Rapidograph but differs somewhat in design, as the inner workings are sealed. Drawbacks: The artist cannot refill or change the ink in the prefilled cartridge.

Dip pens are very economical, consisting of a plastic or wooden holder and changeable steel nibs. With Hunt nib no. 102 (medium) or no. 104 (fine), the Crow Quill dip pen provides a good ink line. It cleans up easily and is useful when many ink changes are required. Drawbacks: Crow Quill pens are limited in stroke direction, must be re-dipped often and tend to drip and spatter.

Other acceptable alternatives include permanent fine-line Micron markers and Koh-I-Noor Nexus Roller Ball pens, which are great for a quick sketch. Both are prefilled with permanent archival-quality ink, come in a variety of colors and are reasonably priced.

Inks

For mixed-media work, choose an ink that is lightfast, compatible with the pen you are using and brushproof (able to withstand the vigorous overlay application of wet washes without bleeding or streaking). Permanent inks are not necessarily brushproof and must be tested. For a very black, brushproof India ink, I recommend Koh-I-Noor's Universal Black India 3080.

For softer, subtle ink lines, choose compatible brushproof colored inks. Transparent, pigmented, acrylic-based inks are preferred, as dye-based inks often fade quickly. I recommend Koh-I-Noor Archival-quality colored inks or Daler-Rowney FW Acrylic Artist Ink (transparent colors).

Brushes

The best watercolor brushes are made of sable hair, Kolinsky sable being the highest quality. Soft, absorbent sable brushes are capable of holding large amounts of fluid color, while maintaining a sharp point or edge. They respond to the hand with a resilient snap. However, they are expensive. A good sable-hair blend or a quality synthetic brush can provide an adequate substitute. Avoid brushes that become limp and shapeless when wet or are so stiff they won't "flow" with the stroke of your hand. Upkeep hint: Use your watercolor brushes only for watercolor.

Paint

Look for a watercolor paint that has rich, intense color, even when thinned to pastel tints. It should be finely ground and well processed, with no particle residue, so washes appear clean. Colors should have high lightfast ratings. The paintings in this book were created using M. Graham & Co. and Winsor & Newton watercolors. References are also made to Grumbacher Thalo and Thio colors (on pages 12 and 13). Whichever brand you choose, remember that it is better to have a limited palette of quality paints than a kaleidoscope of inferior substitutes.

Other Useful Tools

- A no. 2 pencil, pencil sharpener and white vinyl eraser
- Winsor & Newton Art Masking Fluid Clear, to protect white paper areas
- The Incredible Nib (or a dried-up felt-tip marker) or old round brushes for applying masking fluid and liquid soap for coating the brush
- Masking tape for taping paper edges and removing masking fluid
- Liquid Paper correction fluid for fixing small ink mistakes
- 8" (20cm) clear plastic ruler for making size and angle comparisons
- A water container
- White plastic palette with lots of mixing space
- Facial tissues and paper towels for blotting and cleanup
- Texturing tools, including sponges, a razor blade, rock salt, table salt, tweezers, plastic wrap, spray mister, stylus, etc.

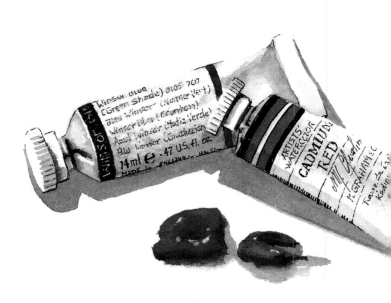

Watercolor Paint

True watercolor is made up of two main ingredients: pigment and a water-soluble gum binder. Water is added by the artist to make the paint fluid and workable.

Artists working with transparent watercolors rely on the white of the paper to create white areas and highlights, and lighten the colors to pastel tints by adding water instead of white paint.

The palette on the left shows six basic "warm and cool" primary mixing colors. From these six it is a simple procedure to mix brilliant secondary colors of green, orange and violet. (Refer to the mixing charts on the following pages.)

Basic palette

Phthalocyanine Blue

* Sap Green

Lemon Yellow

Cadmium Yellow Med. or New Gamboge

* Yellow Ochre

Cadmium Red, Lt.

Quinacridone Rose or Permanent Alizarin Crimson

Ultramarine Blue

* Burnt Sienna

* Payne's Gray

* Sepia

Color wheel

Intermediate colors are mixed from a primary and corresponding secondary color. Intermediate colors include yellow green, blue green, blue violet, red violet, red orange and yellow orange.

Complementary colors are hues which are opposite each other on the outer ring of the color wheel. They provide maximum color contrast. Mixing an outer ring color with its complement will produce shadow tones for the base color-rich browns and neutral grays, depending on how much of the complementary color is added. (See inner ring of color wheel.)

* These are often-used browns and grays that are convenient to have.

Color Mixing Guide Using Six Primary Hues

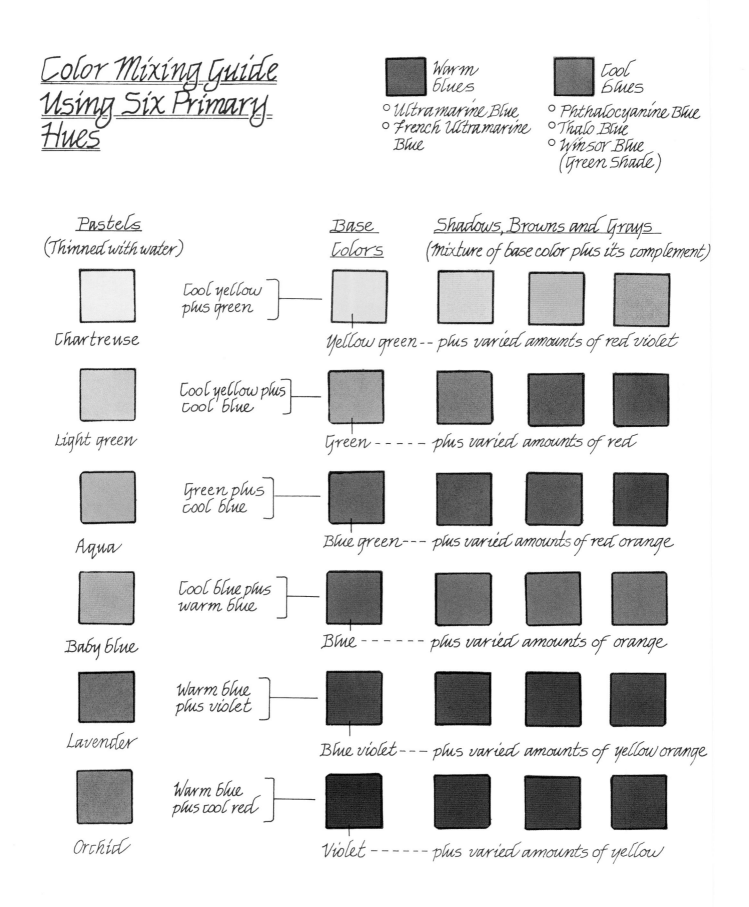

Warm blues
- Ultramarine Blue
- French Ultramarine Blue

Cool blues
- Phthalocyanine Blue
- Thalo Blue
- Winsor Blue (Green Shade)

Pastels
(Thinned with water)

Base Colors

Shadows, Browns and Grays
(mixture of base color plus its complement)

Chartreuse — Cool yellow plus green — Yellow green -- plus varied amounts of red violet

Light green — Cool yellow plus cool blue — Green ----- plus varied amounts of red

Aqua — Green plus cool blue — Blue green--- plus varied amounts of red orange

Baby blue — Cool blue plus warm blue — Blue ------ plus varied amounts of orange

Lavender — Warm blue plus violet — Blue violet--- plus varied amounts of yellow orange

Orchid — Warm blue plus cool red — Violet ------ plus varied amounts of yellow

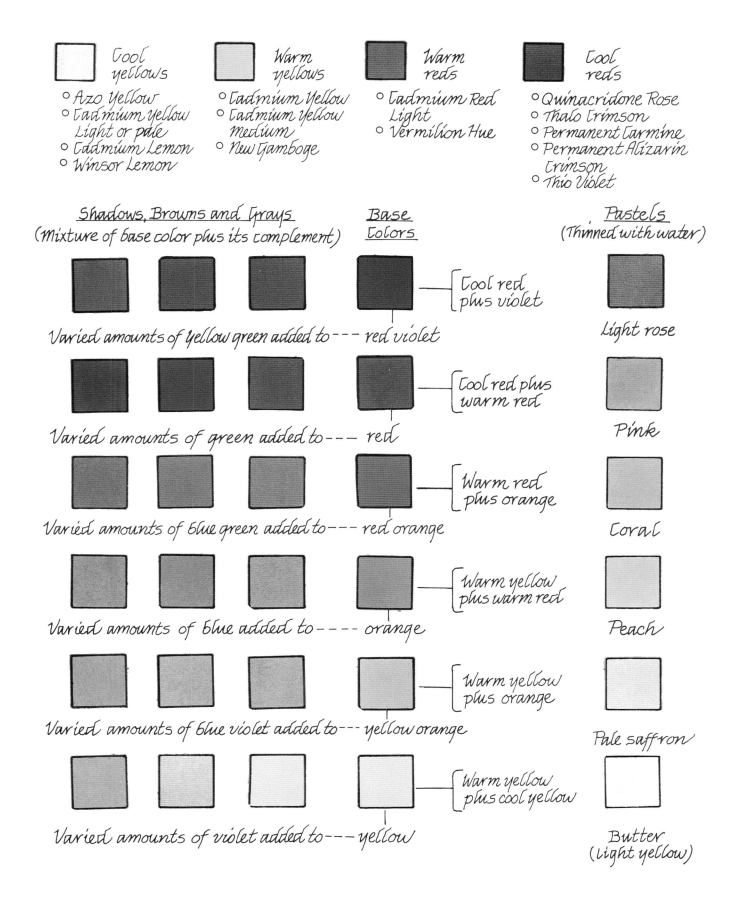

Cool yellows
- Azo Yellow
- Cadmium Yellow Light or pale
- Cadmium Lemon
- Winsor Lemon

Warm yellows
- Cadmium Yellow
- Cadmium Yellow Medium
- New Gamboge

Warm reds
- Cadmium Red Light
- Vermilion Hue

Cool reds
- Quinacridone Rose
- Thalo Crimson
- Permanent Carmine
- Permanent Alizarin Crimson
- Thio Violet

Shadows, Browns and Grays
(Mixture of base color plus its complement)

Base Colors

Pastels
(Thinned with water)

Cool red plus violet

Varied amounts of Yellow green added to --- red violet

Light rose

Cool red plus warm red

Varied amounts of green added to --- red

Pink

Warm red plus orange

Varied amounts of blue green added to --- red orange

Coral

Warm yellow plus warm red

Varied amounts of blue added to ---- orange

Peach

Warm yellow plus orange

Varied amounts of blue violet added to --- yellow orange

Pale saffron

Warm yellow plus cool yellow

Varied amounts of violet added to --- yellow

Butter
(light yellow)

13

The Surface Moisture Content

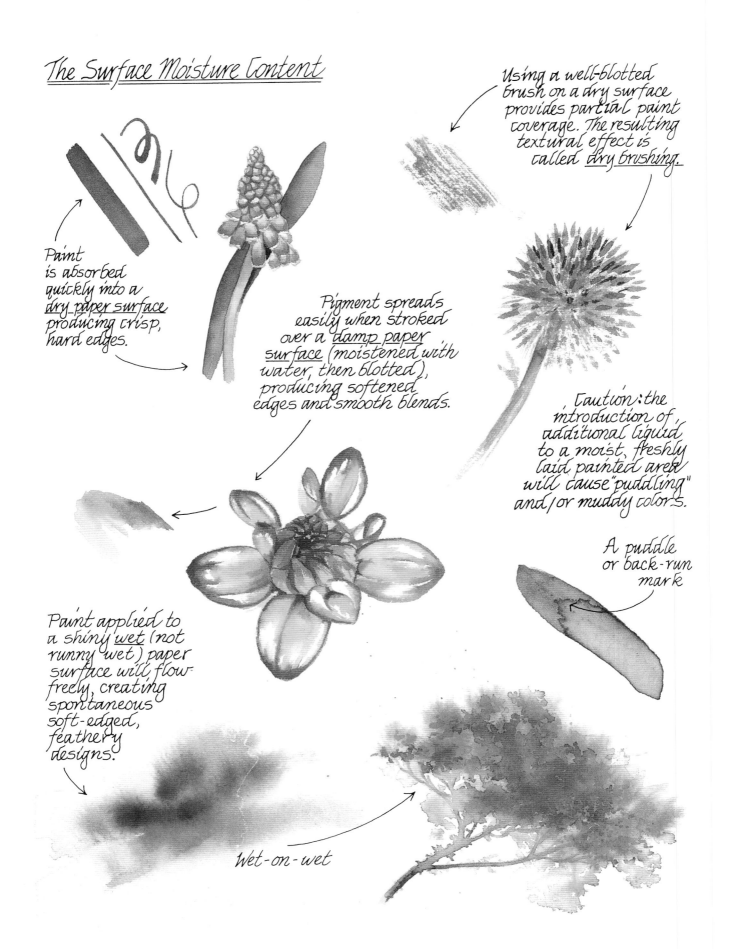

Using a well-blotted brush on a dry surface provides partial paint coverage. The resulting textural effect is called _dry brushing._

Paint is absorbed quickly into a _dry paper surface_ producing crisp, hard edges.

Pigment spreads easily when stroked over a _damp paper surface_ (moistened with water, then blotted), producing softened edges and smooth blends.

Caution: the introduction of additional liquid to a moist, freshly laid painted area will cause "puddling" and/or muddy colors.

A puddle or back-run mark

Paint applied to a shiny _wet_ (not runny wet) paper surface will flow freely, creating spontaneous soft-edged, feathery designs.

Wet-on-wet

The Basic Flat Wash

Washes are very fluid mixtures of water and pigment. When they are brushed quickly and evenly across the paper surface to form smooth colored areas of uniform tone, the result is called a flat wash.

Flat washes can be applied to either a dry or damp surface, but go on smoother and stay workable longer when stroked over a damp paper. The fewer strokes used to lay down the wash, the better.

Flat washes are useful in depicting smooth, flat surfaces, and form an undercoat for glazing. They are the first step in many texturing techniques.

Excess moisture can be "wicked" from the edge of the flat wash with the tip of a clean, blotted brush to prevent "back run" flow marks.

Flat wash

Varied color wash

Graduated wash

Flat wash variations —

Graduated wash

As the wash is stroked over the paper surface, the amount of water or pigment in the wash mixture is increased to gradually change the value.

Varied color wash

The brush is dipped in several different colors as the wash is laid down. For bright, pure colors, rinse and blot the brush between color changes. Avoid overworking and overblending the wash.

Color Blending and Softened Edges

Blending and softening works best on freshly laid washes that are still moist. Once dry, the pigment in a thin wash of paint is very hard to move! Drying time can be prolonged by working on a damp surface.

Softened edge

①

Softening a hard edge

1. While the wash is still moist and workable, place a clean, freshly rinsed and well-blotted no. 4 round brush on the top of the edge to be softened. Using a wiggly, spiral motion, pull the brush along the edge. Stop every 1/4 to 1/2 inch to rinse out the brush and blot it. This cleaning step is critical in preventing the spread of darker pigment into light areas.

Softened edge

2. If a flat brush is used for softening lengthy edges, straddle the edge and stroke straight along. Re-stroke the edge several times, remembering to clean and blot the brush every few strokes.

②

Blended color

③

Blending two colors together

3. Lay down the colors side by side on a damp surface. Depending on the amount of moisture present, they may begin to flow together spontaneously. Use either the round or flat brush-stroking techniques to help the colors mingle and blend. Cleaning and blotting the brush often is very important. Don't over-work it!

Using Masking Fluid

Masking fluid is useful in preserving white paper areas while laying down a wash, or to protect painted areas from subsequent washes.

Liquid masking was used to protect these white bleeding heart flowers while the dark background washes were applied. Then a round detail brush was used to add a little color and dimension to the blossoms.

Masked areas will have hard, well-defined edges.

① This allium flower began with a pale rose wash, which was allowed to dry completely.

② Individual flowers were pencilled in and masked out.

③ Darker washes were added and the masking removed.

④ Details were added.

Tips for application —

- Use an old, dried-up felt-tip marker, the "incredible nib" application tool or an old synthetic brush, to stroke on the masking fluid. Coat the tool or brush with liquid soap to protect the fibers. Clean and re-soap often.

- If the masking fluid has become thickened and gummy, thin it with a little water.

- Apply masking fluid only over a very dry surface. Use thin coats and let it dry thoroughly.

- Remove masking fluid when over laying washes are completely dry, using a rubber cement remover or piece of masking tape rolled around your finger, sticky side out. Use a daubing motion, rather than harsh side-to-side rubbing, which can loosen and lift paint.

- For the best results, liquid frisket or masking fluid should be removed within a few hours or a day or two at the most.

Glazing

Glazing is the process of laying a thin wash over a dry, painted area to intensify the color, darken the value or change the hue.

When two washes of the same pigment/water mix are glazed one over the other, the color intensity will increase where they overlap (A).

When complementary colors are glazed one over the other, muted shadow tones will result (browns and neutral grays). (B)

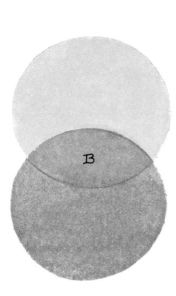

Glazing was used to give the viola petals a transparent look and ruffled edges.

Glazing can be used to create "transitional color zones" between distinct hues. This is a very effective color blending technique. (C, D and E)

The center (F) has three overlapping layers of paint making it more gray in tone.

Basic Texturing Techniques

<u>Scraping</u>- lines were scratched in a dry wash with a razor blade. This is a good way to add high-lights.

<u>Bruising</u>— A stylus was stroked over the surface of a moist wash which compressed the paper surface and caused the pigment to gather into dark lines.

<u>Scraping</u> a blunt tool through an almost dry wash will push pigment aside, forming light streaks.

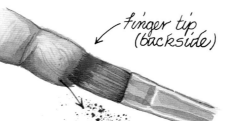

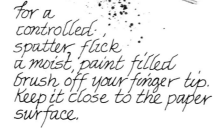

finger tip (backside)

<u>Water spatter</u> spots are created when fine water drops are flicked into a moist wash.

for a controlled spatter, flick a moist, paint filled brush off your finger tip. Keep it close to the paper surface.

<u>Spatter</u> on both a dry surface (left) and a damp surface (right).

<u>Lifting</u> - A clean, damp, blotted brush was pressed into a moist wash to "lift" away pigment.

<u>Blotting</u>- A facial tissue was crumpled and gently rolled through a moist wash, leaving a random pattern.

<u>Blotting</u> - A textured paper towel was folded into several thicknesses and gently pressed into a moist wash.

Creating Special Effects

Salt texturing

① Remove humidity from the table salt by microwaving it on high for one minute (spread it out on a paper towel). Let cool.

② Lay down a damp surface wash. While it is still shiny with moisture, sprinkle on the salt, *sparingly*.

③ The salt will draw moisture and pigment to it and turn dark. If there is not enough moisture surrounding each salt crystal to continue the process, the texture will remain as dark dots.

④ Given plenty of moisture, the salt will melt, pushing the pigment away and forming pale, star-like designs. Brush the salt off when dry.

for large, flower-like patterns, dip rock salt crystals in water and lay them into a moist wash with tweezers. Remove the crystals when dry.

Impressed, crumpled plastic wrap formed these patterns.

Impressed Textures

Dark impressions are created when an object is pressed into a very moist wash, secured in place and left undisturbed until dry.

Sage, lobelia and oak fern

Interesting backgrounds can be created by pressing young, tender flowers and leaves into a wet wash. (Pat them into place using a moist brush). Let them dry totally before removing.

Caution: Peeking prematurely will spoil the leaf impression!

Sponging and stamping

Tender leaves can be painted and "stamped" onto dry paper.

A damp kitchen sponge brushed with paint, blotted and pressed onto dry paper will produce a pebble-like design.

A damp sea sponge dipped in paint, blotted and daubed onto a dry paper surface will create a feathery foliage pattern.

Enhanced with light glazes and some shadow detail work.

Glazing can enhance the color and form of a leaf print.

Note: For best results place a paper towel over the painted leaf and rub with index finger.

Thrown trees and shrubs

A. Begin with splats of cream-thick wash flung onto the dry paper surface from a brush. (Protect surrounding areas with paper towels.)

A

Caution: Keep the water spray light and airy.

B.

B. While still wet squirt the splat puddles with water in a spray bottle. The paint will flow into lacy foliage patterns.

(Create light areas by blotting.)

Pen and Ink Techniques

Contour Lines
(Smoothly flowing, form-fitting strokes)

· smooth, curved objects, petals
· polished surfaces
· fluid motion, moving water
· glass, metal

Cross hatching
(Two or more intersecting lines)

· deepened tonal values, heavy shadows
· roughened texture varying in degrees according to angle, precision and nib size
· leaves, stone, rusty metal seen at a distance

Parallel lines
(Straight, free hand lines stroked in the same direction)

· Smooth, flat objects
· faded, hazy, misty or distant-looking objects
· backgrounds
· objects seen under water

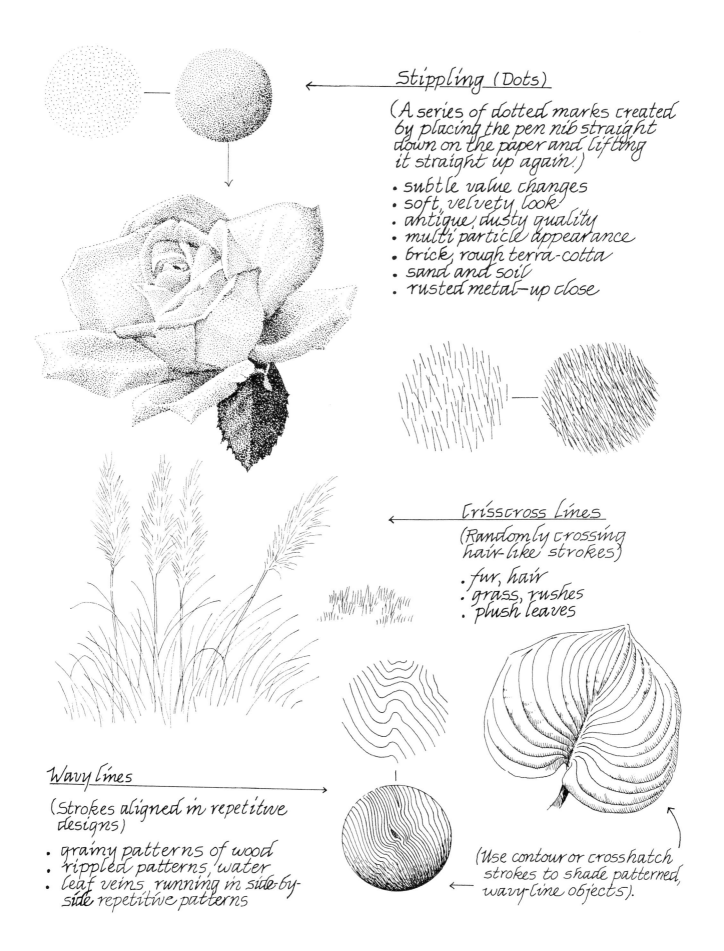

Stippling (Dots)

(A series of dotted marks created by placing the pen nib straight down on the paper and lifting it straight up again.)

- subtle value changes
- soft, velvety look
- antique, dusty quality
- multi particle appearance
- brick, rough terra-cotta
- sand and soil
- rusted metal—up close

Crisscross Lines

(Randomly crossing hair-like strokes)

- fur, hair
- grass, rushes
- plush leaves

Wavy lines

(Strokes aligned in repetitive designs)

- grainy patterns of wood
- rippled patterns, water
- leaf veins, running in side-by-side repetitive patterns

(Use contour or crosshatch strokes to shade patterned, wavy-line objects).

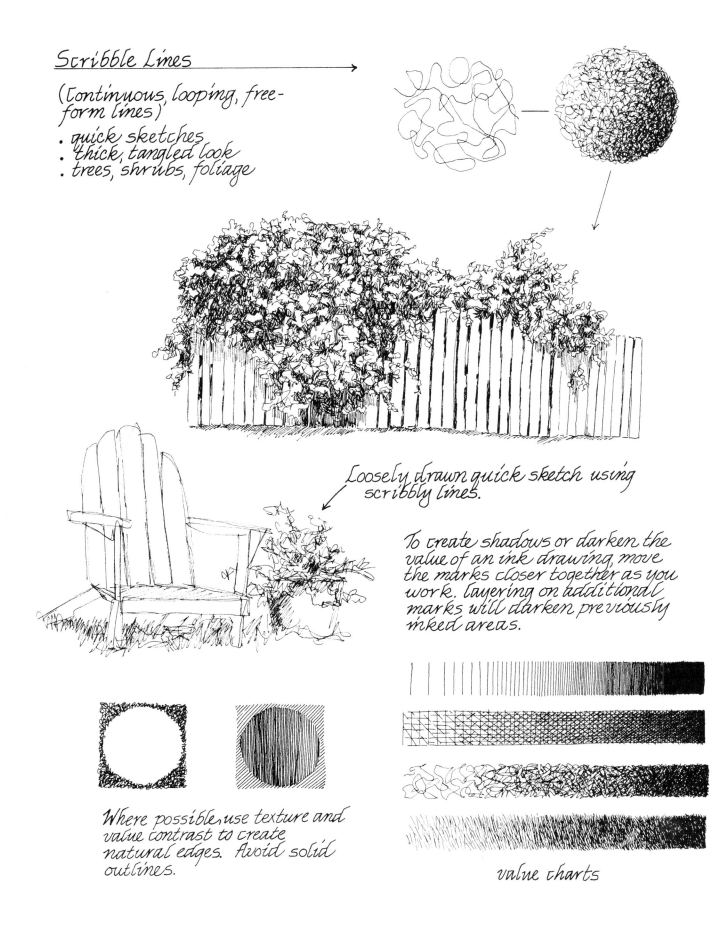

Scribble Lines

(Continuous, looping, free-form lines)

- quick sketches
- thick, tangled look
- trees, shrubs, foliage

Loosely drawn quick sketch using scribbly lines.

To create shadows or darken the value of an ink drawing, move the marks closer together as you work. Layering on additional marks will darken previously inked areas.

Where possible, use texture and value contrast to create natural edges. Avoid solid outlines.

value charts

Pen Blending

When pen strokes are applied to a moist surface, the ink marks will feather outward, creating softened edges and spontaneous "flares." The unpredictability of this technique adds a touch of fun and adventure to the creative process.

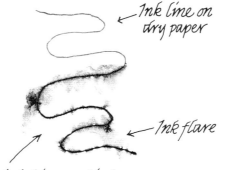

← Ink line on dry paper

← Ink flare

Ink line applied to water-moistened surface.

Marble look was created by stroking brown ink lines into a moist, varied color wash.

To prepare an area for pen blending, dry watercolor paper or dry washes may be lightly moistened with water applied with a brush. Leave only a sheen of moisture on the surface. Wet areas will inhibit the ink flow.

Pen blending subtly separates the stones in the pathway below.

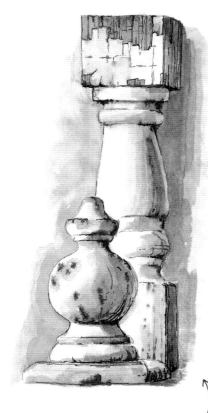

Pen blending with Burnt Sienna and India ink in .25 nibbed pens adds a distinct look of age to these weather-worn finials.

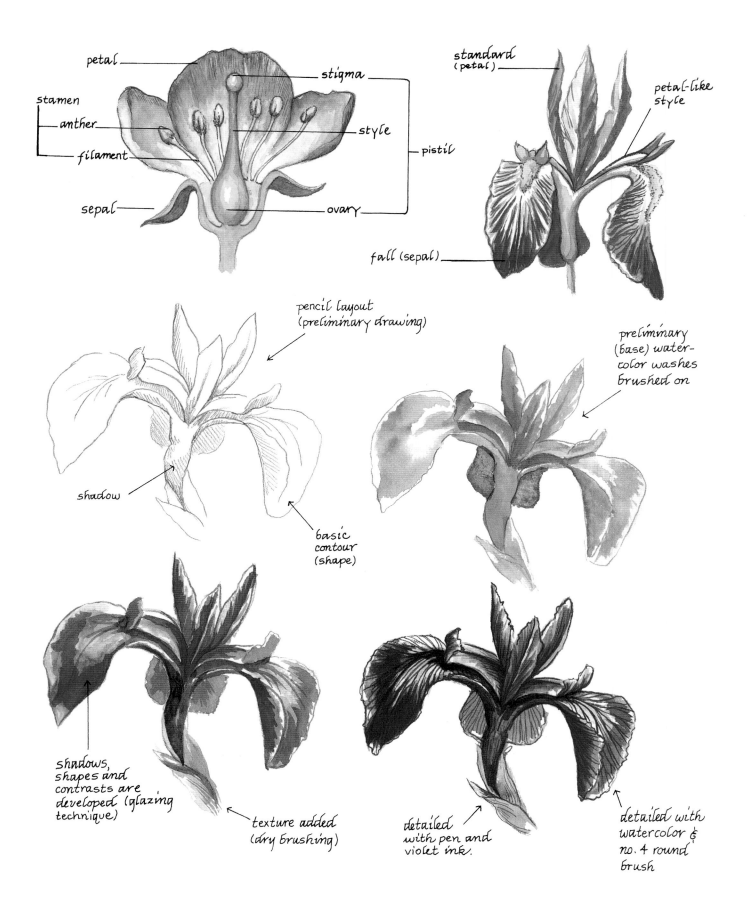

petal

stigma

stamen

anther

style

filament

pistil

sepal

ovary

standard (petal)

petal-like style

fall (sepal)

pencil layout (preliminary drawing)

shadow

basic contour (shape)

preliminary (base) water-color washes brushed on

shadows, shapes and contrasts are developed (glazing technique)

texture added (dry brushing)

detailed with pen and violet ink.

detailed with watercolor & no. 4 round brush

Creating Lifelike Florals

There is nothing still about florals. They may be called still lifes when plucked and placed in a vase, but there is vitality in those blooms. Even the leaves I gathered and carried into my studio (page 41) refused to lay quiet while I sketched. In the two hours it took me to paint them, the maple leaf managed to curl into a completely different shape. Was it just drying out or dancing a ballet to the ebb and flow of life? It's this life force and the vibrant beauty of the florals that make them such an appealing subject. It's up to the artist to capture that essence.

The purpose of this chapter is to review some basics for portraying florals and introduce some fun, nontraditional ideas all with the hope that it may be helpful to you in creating livelier floral depictions.

Begin with the senses. Forget the preconceived ideas of shape and color. Take a walk in the garden and let your eyes caress the blossoms as if you are seeing them for the first time. Note the curve of the petal, the twist in the leaf and the jaunty angle of the stem. Study them from all directions. Touch them! Feel the smoothness of the rose petals, the soft pelt of the lamb's ear leaf, and the harsh stiffness of the sunflower stalk. Sniff the garden fragrances and listen to the breeze play among the plants. Linger and develop an intimacy with your subject. On an intellectual level, familiarize yourself with botany basics so you will recognize what you are looking at. Remember, you can successfully draw that which your mind sees well, and you will see only what you look for. Now take a deep breath and begin to draw. Simplifying the shapes into geometric contours will help. To remove the stiffness from your flowers, complete a drawing without looking down at your paper. The result will be primitive, whimsical and full of movement. This is a great way to break your inhibitions and loosen up. Combine the two drawing methods, and your work will begin to have that spark of vitality. From there it's practice, practice, practice!

The key to completing your sketch as a pen-and-ink drawing is contrast. Use contrast of value and texture to form contours and edges. Keep in mind the delicate nature of the subject—be bold, not harsh.

Watercolor is the perfect medium to portray transparent petals, sun-dappled leaves and the vibrancy of floral hues. My personal favorite floral technique is glazing (shown in progressive steps in the iris study to the left). This is only the beginning. Add the spontaneity of wet-on-wet, a bit of impressed texture and a touch of colored-ink detailing, and there is no end to the lively florals you can portray. Now mingle with the flowers, get inspired, and have some creative fun!

Drawing the Flower

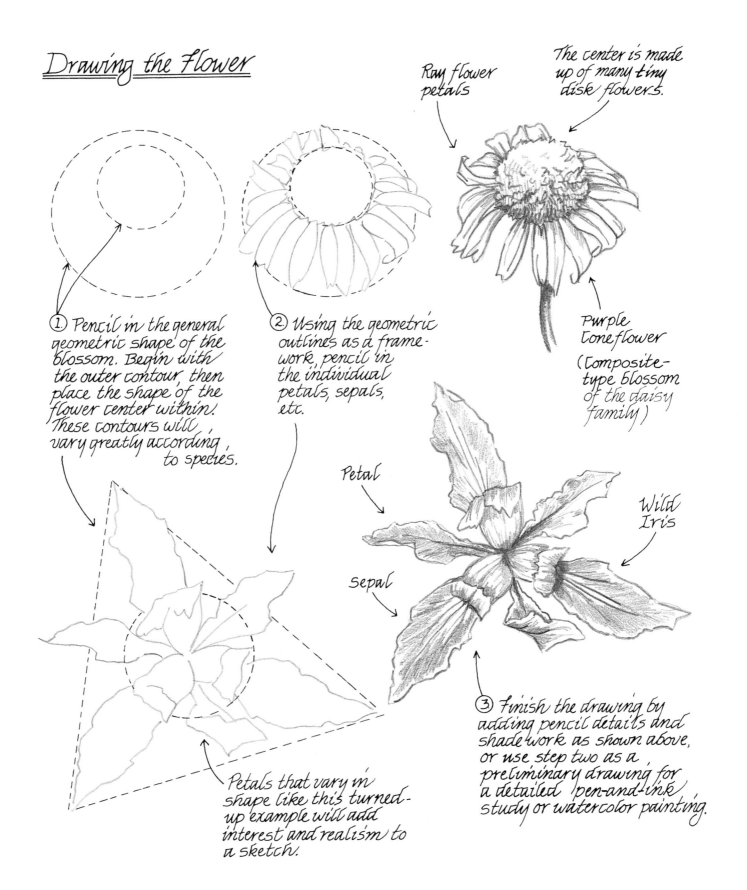

Ray flower petals

The center is made up of many tiny disk flowers.

① Pencil in the general geometric shape of the blossom. Begin with the outer contour, then place the shape of the flower center within. These contours will vary greatly according to species.

② Using the geometric outlines as a framework, pencil in the individual petals, sepals, etc.

Purple Coneflower (Composite-type blossom of the daisy family)

Petal

Sepal

Wild Iris

Petals that vary in shape like this turned-up example will add interest and realism to a sketch.

③ Finish the drawing by adding pencil details and shade work as shown above, or use step two as a preliminary drawing for a detailed pen-and-ink study or watercolor painting.

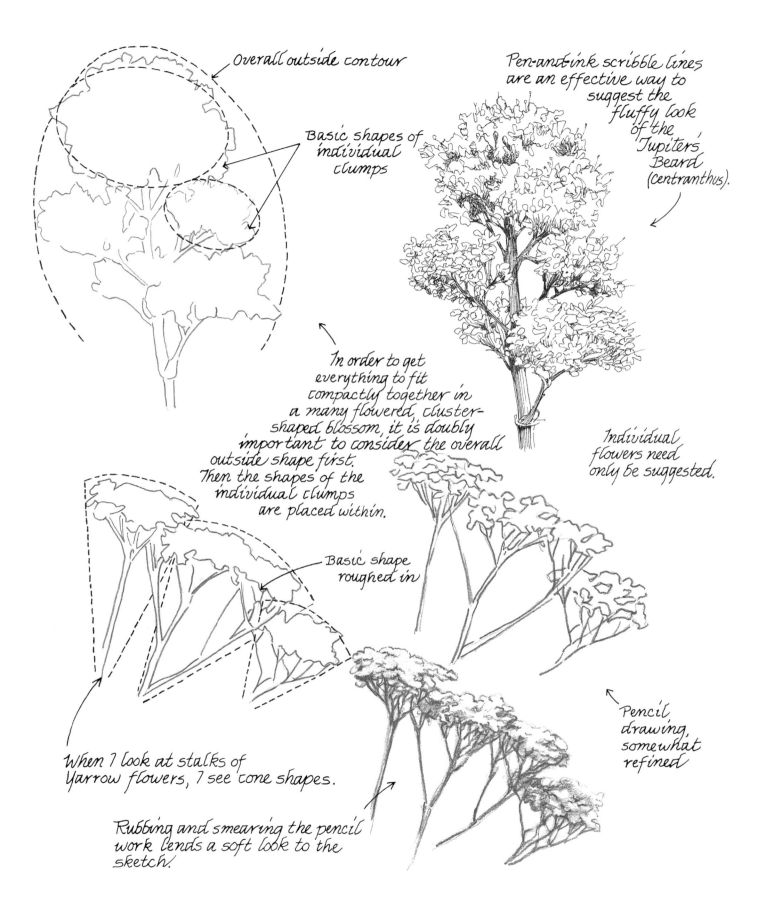

Overall outside contour

Basic shapes of individual clumps

Pen-and-ink scribble lines are an effective way to suggest the fluffy look of the Jupiter's Beard (centranthus).

In order to get everything to fit compactly together in a many flowered, cluster-shaped blossom, it is doubly important to consider the overall outside shape first. Then the shapes of the individual clumps are placed within.

Individual flowers need only be suggested.

Basic shape roughed in

When I look at stalks of Yarrow flowers, I see cone shapes.

Rubbing and smearing the pencil work lends a soft look to the sketch.

Pencil drawing, somewhat refined

29

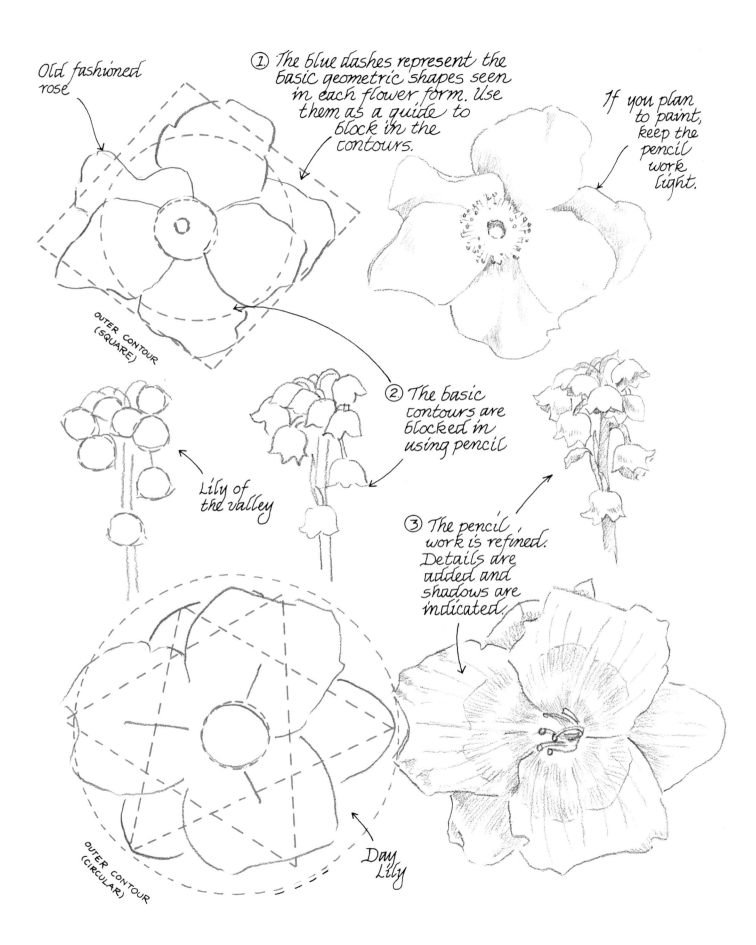

Old fashioned rose

① The blue dashes represent the basic geometric shapes seen in each flower form. Use them as a guide to block in the contours.

If you plan to paint, keep the pencil work light.

OUTER CONTOUR (SQUARE)

② The basic contours are blocked in using pencil

Lily of the valley

③ The pencil work is refined. Details are added and shadows are indicated.

OUTER CONTOUR (CIRCULAR)

Day Lily

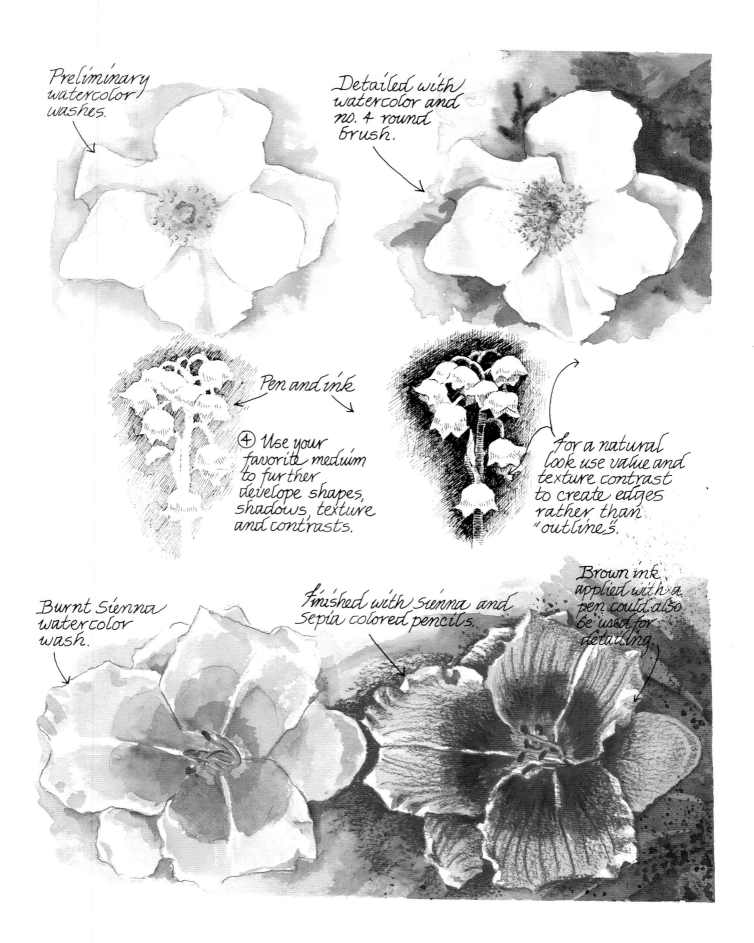

Preliminary watercolor washes.

Detailed with watercolor and no. 4 round brush.

Pen and ink

④ Use your favorite medium to further develope shapes, shadows, texture and contrasts.

For a natural look use value and texture contrast to create edges rather than "outlines."

Burnt Sienna watercolor wash.

Finished with sienna and sepia colored pencils.

Brown ink applied with a pen could also be used for detailing.

from Start to finish Using the Glazing Technique

Amaryllis

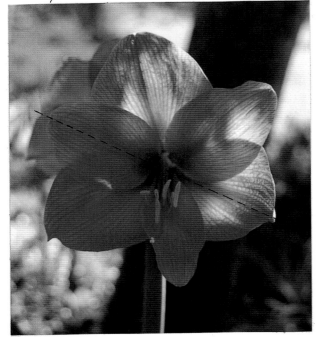

① Study the subject. Decide the outer shape of the flower – a circle. (Shown here in brown for clarity). Now look for geometric shapes within the blossom that might be helpful. I saw two triangles (shown in orange). Pencil in these geometric guide-lines lightly.

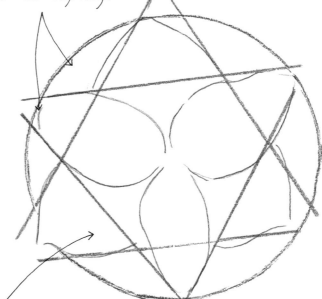

② Block in the petal shapes in pencil. Preliminary sketches may be done directly on the work surface (keep it light), or on another piece of paper and transferred later on.

③ Erase the geometric guidelines, make corrections and refine the shapes. Straight edges are helpful in making comparisons between the subject and the drawing. Compare this angle with the photo.

④ Pencil in details.

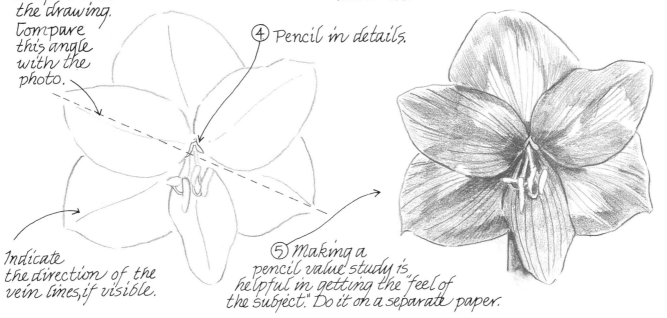

Indicate the direction of the vein lines, if visible.

⑤ Making a pencil value study is helpful in getting the "feel of the subject." Do it on a separate paper.

⑥ If the subject has not been drawn on the work surface, transfer it there using a pencil-rub transfer, lightbox or pencil tracing done at a sunlit window.

There is a blush of yellow orange here.

a. b. c. d.

Cadmium Red Lt. with a hint of blue green added.

⑦ Experiment with color mixtures, testing them on scrap paper.

Shadow color- more blue green added.

d.
b. b.
c. d.
b.

⑧ Pre-dampen the area to be painted, blot, and brush on the washes. These are the palest tints in each area. Leave white, unpainted places where appropriate, and use a clean, damp brush to lift and lighten the color as needed. Blend edges that need to be soft as you work along. Let the first "base" washes dry completely before beginning the glazing process.

⑨ Glazing— the next darkest value is brushed on over the base, leaving the base color to show through where appropriate. (On the petals this would be mixture b.) Use the photo as a visual guide and soften edges where needed as you work along. The paper does not need to be re-dampened for glazing except where the base coat is very thin. Let each layer dry before adding the next. The second glaze (mix c.) is used only where the petal color is very intense. The last glaze layer is the shadow (mixture d.) The example above shows various stages of completion, so you can see how it looks as it progresses. Each petal is marked with the last glaze mix applied.

⑩ The last step is to refine and detail the flower, taking care not to overwork it. When it looks good—stop!

Amaryllis blossoms have lovely vein patterns. Depict them using color mixtures c & d, applied with a small detail brush, or portray them with pen and red ink using the pen-blending technique. (I chose the brush method.)

Depicting White Blossoms

White flowers need to be kept white! No other color can represent them in their purity. Therefore leave plenty of un-inked or unpainted white areas. The exceptions are areas of shadow or areas that reflect surrounding color. To suggest blossoms basking in the sunlight, begin with warm pastels and create shadow mixtures by adding their complement.

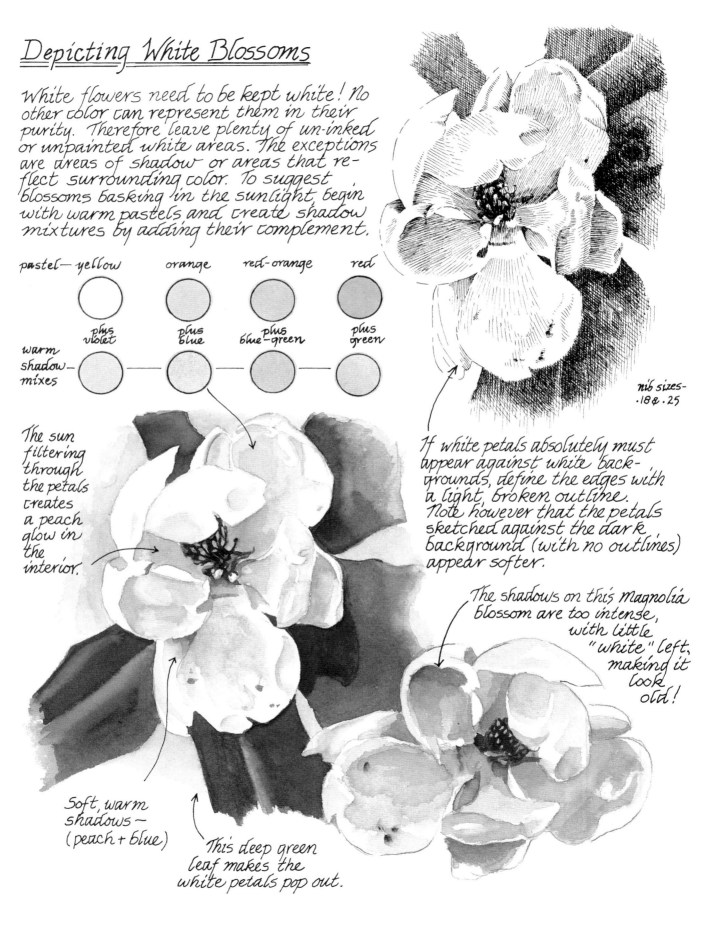

pastel— yellow orange red-orange red

plus violet plus blue plus blue-green plus green

warm shadow— mixes

nib sizes— .18 & .25

The sun filtering through the petals creates a peach glow in the interior.

If white petals absolutely must appear against white backgrounds, define the edges with a light, broken outline. Note however that the petals sketched against the dark background (with no outlines) appear softer.

The shadows on this Magnolia blossom are too intense, with little "white" left, making it look old!

Soft, warm shadows — (peach + blue)

This deep green leaf makes the white petals pop out.

34

①

To depict detailed clumps of leaves, the following mixed-media technique works quite well.

① Begin with loosely drawn leaf shapes in pencil.

② Lightly outline each leaf with pen and ink. (Brown ink was used.)

Foliage Groupings

③ Shade in the background to "pop out" the leaves, then add a bit of shadework to the leaves themselves. (Parallel lines).

Same technique, different leaf shapes

④ Tint the sketch with watercolor washes.

Flat brush stippling

Masked-out leaves

Round brush "tip prints"

Wet-on-wet free flow

Table salt (in corner)

Black ink

Making Distant Brush-Tip Leaves

My favorite way of depicting leaves seen in a distant landscape setting is with the tip of a no. 4 round detail brush. Choose a brush with a nice point, preferably a sable so it will retain its moisture content longer.

Simple one-stroke leaves

① Dip the brush in a fluid wash of paint and let it wick up the hairs, almost to the ferrule. Blot the brush tip on a paper towel, to prevent the brush from flooding the work surface.

② Touch the brush tip to a dry or slightly damp watercolor paper. The brush tip will form the tip of the leaf. Press downward gently so that about half the side of the brush rests against the paper. Pull the brush away from the tip of the leaf and lift. The longer the stroke, the longer the leaf.

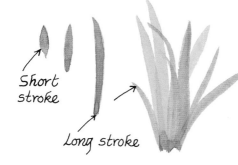

Short stroke

Long stroke

More pressure

Less pressure

1. 2.

An extra wide leaf, can be created by using two strokes that curve slightly to the right and left, and join at the top and bottom.

Palmate leaf
Five to seven strokes that meet in the middle

Basic shape

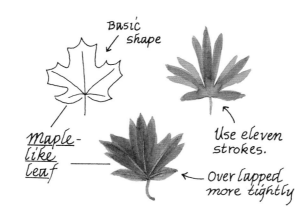

Maple-like leaf

Use eleven strokes.

← Over lapped more tightly

By over lapping the strokes, new leaf shapes can be suggested.

Basic stroke
a.

Heart-shaped leaf

a.

b. | c.

Three strokes joined together become this.

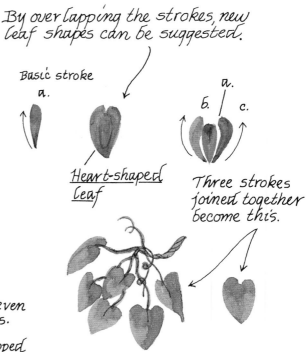

Backlit foliage clumps —

Foliage clumps are a main ingredient in the creation of garden landscapes. They will vary in color and leaf shape, but most can be easily rendered using glazing and brush-tip shapes.

Sap Green

① Begin with the lightest shade of green and set down the general shape with a tapping motion of the brush. Color should be slightly uneven in value. Let the wash dry.

② Using the same wash, glaze on a second layer of paint. Make single-stroke, brush-tip leaf shapes. Don't cover the first layer completely. Let some of the preliminary coat show through, especially at the upper edges. Let dry.

③ Glaze on more leaf shapes using a darker mix of paint. Allow the first two layers to show through to suggest sunlight shining on the back of the clump. Let dry.

Sap Green plus Payne's Gray

④ Tap in some deep shadows in the inner and lower parts of the foliage clump. A few detailed flower stalks provide the finishing touches.

To be masked out

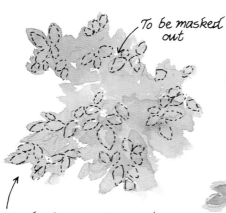

To depict <u>sunlit foliage</u> begin as shown in ① above. Mask out the leaf sprigs you wish to be highlighted by the sun. (Shown in dotted lines.)

Second masking

Heavy shadow area

Tap a slightly darker green over the foliage using a round brush. Let that layer dry and mask out a few more leaves. Do not mask in areas of heavy shadow.

Next add the dark greens, let dry and remove the masking.

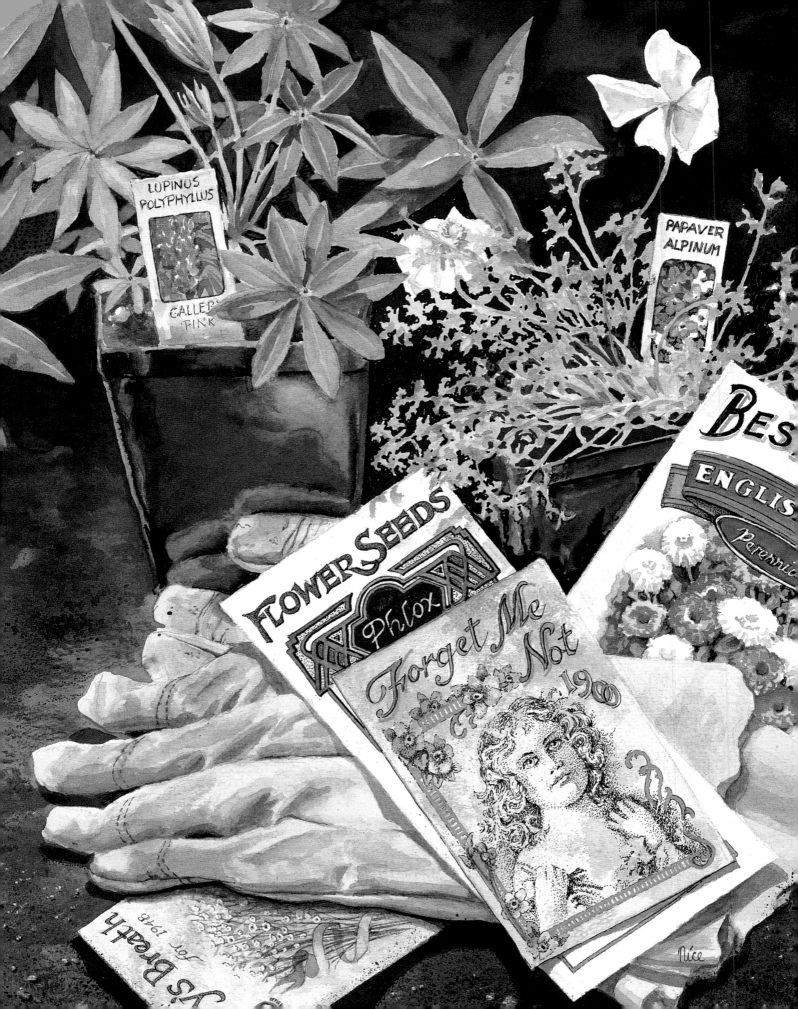

Out of the Good Earth

I cherish the first day of spring. Not the official day the calendar states, but the one nature proclaims. It's that special day each year that first offers the warmth of the sun. It shines so brightly you can feel it through your coat, so you promptly remove it to let the sunrays touch your skin. On that day there is a special smell of rich warm soil and the perfume of faraway blossoms carried in the wind. In the garden the spring bulbs are eagerly rising from the earth and ready to burst into bloom. It's then that I know spring has arrived. I have an unconscious ritual that happens on that special day. Somehow I always find my fingers in the soil. They pluck at baby weeds, caress the stems of budding daffodils, and stain themselves by prowling impatiently in the places where perennials will soon appear. As I wash the soil from my hands, my mind turns to spring planting. Images of seed packets and four-inch plastic pots full of summer promise dance tantalizingly into view. The painting on the opposite page is an expression of those feelings. It represents five generations of gardeners in my family.

This chapter rejoices in the vibrancy of spring and all the feelings it invokes. May it inspire you not only to stain your fingers in the soil, but to paint with a renewed effort the springtime beauty that surrounds you during this poignant season.

SPRING PLANTING
8" x 10" (20cm x 25cm) Watercolor detailed with pen and ink

The Texture of Soil

Just as soil make-up and color may vary from place to place, ways to depict the soil are also quite numerous. I usually begin with a flat or varied wash applied over a damp surface. Then I add a little texture using various techniques.

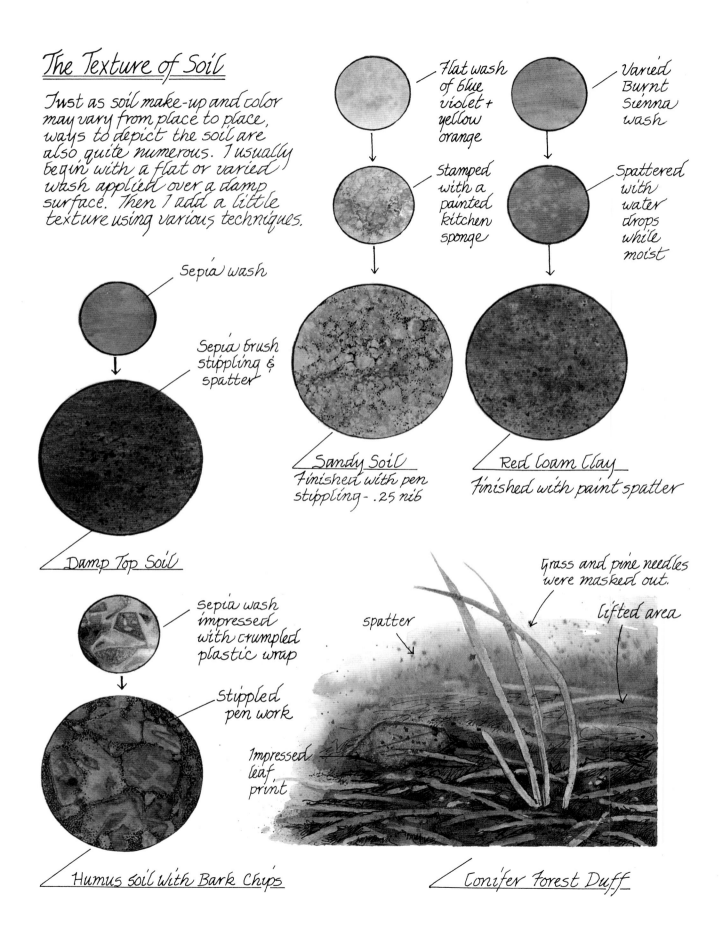

Flat wash of blue violet + yellow orange

Varied Burnt Sienna wash

Stamped with a painted kitchen sponge

Spattered with water drops while moist

Sepia wash

Sepia brush stippling & spatter

Sandy Soil
Finished with pen stippling - .25 nib

Red Loam Clay
Finished with paint spatter

Damp Top Soil

Sepia wash impressed with crumpled plastic wrap

Stippled pen work

Impressed leaf print

spatter

Grass and pine needles were masked out.

lifted area

Humus Soil with Bark Chips

Conifer Forest Duff

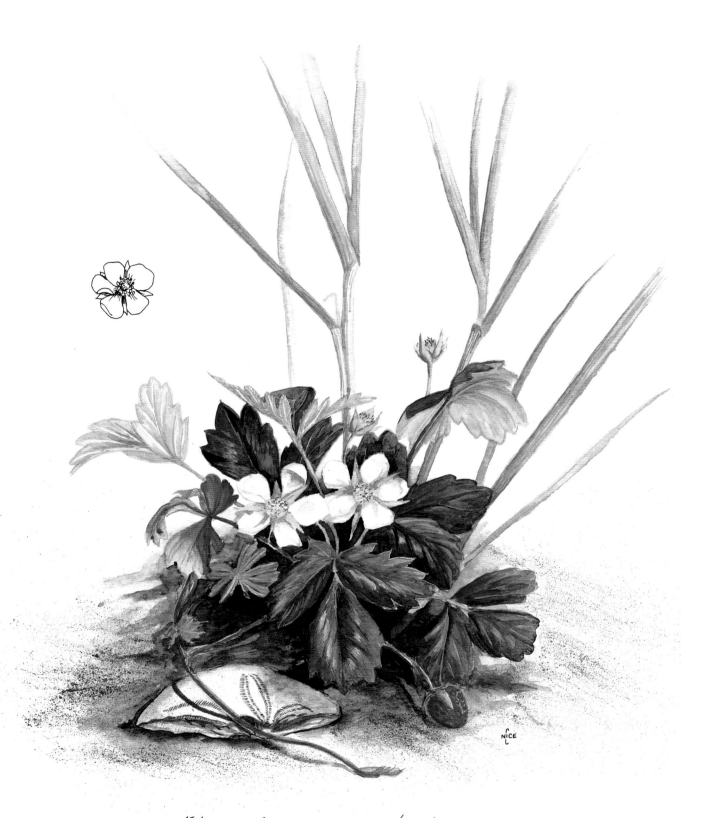

This strawberry study was painted from plants
seen growing in a coastal garden. Note how the
fine spatter lends the gritty texture of sand to
the soil. The broken sand dollar shell helps
to give the "beach look" to the scene.

Creating a Rich Soil Background

I often find I want the illusion of a rich soil backdrop behind my painted garden flowers without depicting all the details. Here's a technique that will provide an "earthy" background and allow you to work in as much color as you like in the process.

A pencil study will allow you to experiment with value placement before you begin painting.

Narcissus flower

Burnt Sienna with a touch of violet

① Begin the painting by blocking in the colors in both the foreground and background. Maintain a good value contrast.

② Detail the flower using glazing techniques. Add color to the background by stippling on dots or scribbly dashes of colored ink. I added dashes of green, yellow and orange to reflect some of the foreground color.

③ Finish the background by stippling it over all with dots or dashes of sepia brown ink. I used a Nexus roller ball pen. It gives the soil a bit of an impressionistic look.

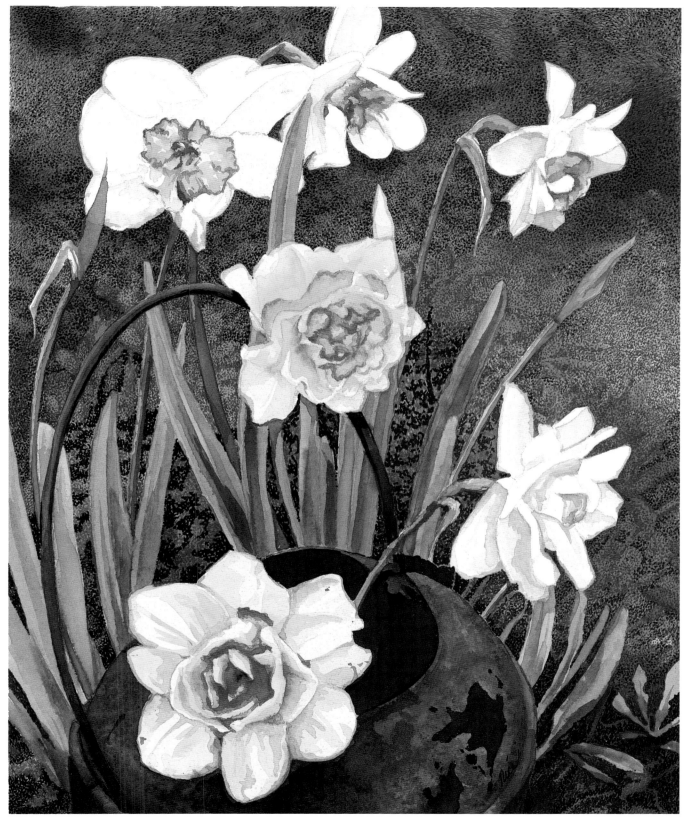

DOUBLE NARCISSUS AND A RUSTY SMUDGE POT
8" x 10" (20cm x 25cm) Watercolor with pen stippling in the background

Floral Miniatures

Drawing or painting groupings of spring flowers as they make their appearance in the flower bed is a great way to explore shapes, color and contrast. They also make wonderful greeting cards and wall groupings.

Dark backgrounds provide vivid contrast and suggest the wet, rich earth seen in freshly worked springtime gardens. Both of the backgrounds in the paintings on this page began as dark sepia washes. Once dry, the tulip background was layered with a dark blue/green wash to darken and richen the tone.

Tulips

Primroses

The sepia wash in the primrose background was stippled with green ink in a Nexus pen.

In both these mini-florals, the flowers and foliage were painted first and the dark background was filled in around them.

Designing a Garden Landscape

There are quite a few things to consider when planning a composition.

① First you need an idea and a center of interest to be the focus of that idea. Familiar scenes, places you've seen and experienced, are the easiest to relate to and usually make the best compositional material.

② Plan how you will call attention to your center of interest. Heavy shadows, vivid colors, interesting textures, strong contrasts and lines leading to the main subject are all ways of declaring the main focus.

My preliminary idea, conceived from sketches and photos I took while visiting the Cotswold countryside in England.

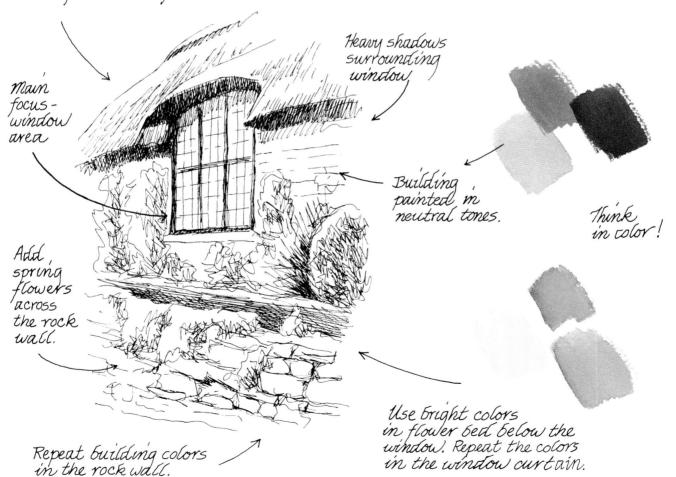

Main focus - window area

Heavy shadows surrounding window

Building painted in neutral tones.

Think in color!

Add spring flowers across the rock wall.

Repeat building colors in the rock wall.

Use bright colors in flower bed below the window. Repeat the colors in the window curtain.

③ Test out your concepts with a thumb-
nail sketch. This preliminary layout
will allow you to check out the proposed
design.

④ If you are unsure how well the
proposed colors will work together,
a quick color study is a good
idea.

Keep these preliminary
sketches simple.

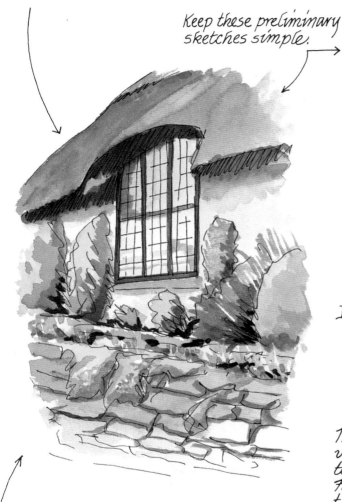

Design elements:

. Shapes and lines
. Values (lights and darks)
. Texture
. Color
. Edges (hard and soft)

Note how the dark shapes and
values, along with the bright
colors of the flowers and
shrubs, help the eye continually
circle the window and focus
on it as the main subject.

In a well-designed composition, the
various elements should work together
to form a pathway for the eye to follow.
First they should lead the viewer to
the center of interest, then conduct a
tour throughout the rest of the
composition, returning again to
focus on the main subject. Any
elements that compete with or
overwhelm the main subject should
be avoided.

⑤ With the design well thought out, it's time to paint the painting ⟶

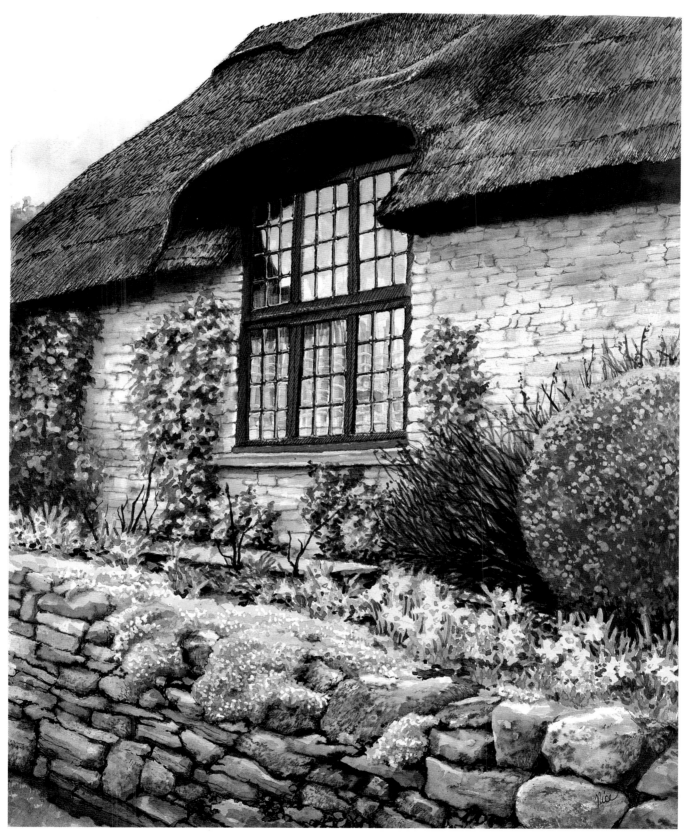

SPRINGTIME COTTAGE GARDEN
8" x 10" (20cm x 25cm) Watercolor detailed with pen blending in Sepia and India ink

Animals in the Garden

Animals are almost as common in my garden as the flowers I plant there. There's the cat that naps beside me while I weed and the dog that stands guard. Then there's the wild things that scamper, hop and glide through. Depicting them is fun and they make an eye-catching center of focus.

NICE

© Susan Scheewe Publications

56

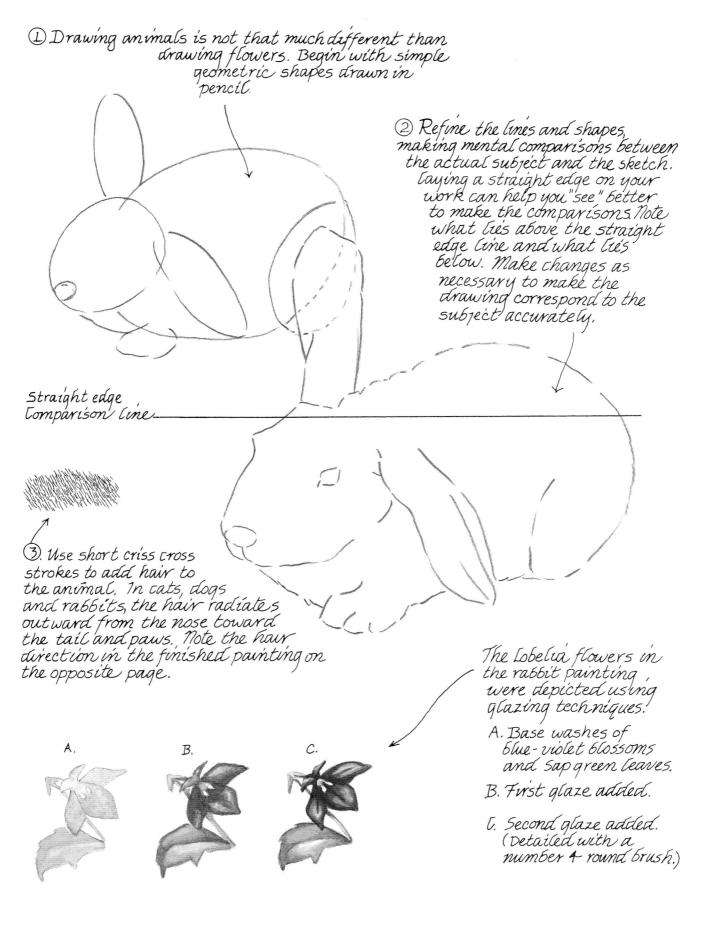

① Drawing animals is not that much different than drawing flowers. Begin with simple geometric shapes drawn in pencil.

② Refine the lines and shapes, making mental comparisons between the actual subject and the sketch. Laying a straight edge on your work can help you "see" better to make the comparisons. Note what lies above the straight edge line and what lies below. Make changes as necessary to make the drawing correspond to the subject accurately.

Straight edge
Comparison line

③. Use short criss cross strokes to add hair to the animal. In cats, dogs and rabbits, the hair radiates outward from the nose toward the tail and paws. Note the hair direction in the finished painting on the opposite page.

A. B. C.

The Lobelia flowers in the rabbit painting, were depicted using glazing techniques:

A. Base washes of blue-violet blossoms and sap green leaves.

B. First glaze added.

C. Second glaze added. (Detailed with a number 4 round brush.)

The hair in the dog painting below began with a moist surface wash applied in the shadow areas. The edges were allowed to "feather out" and soften naturally.

Payne's Gray & Ultramarine Blue mix

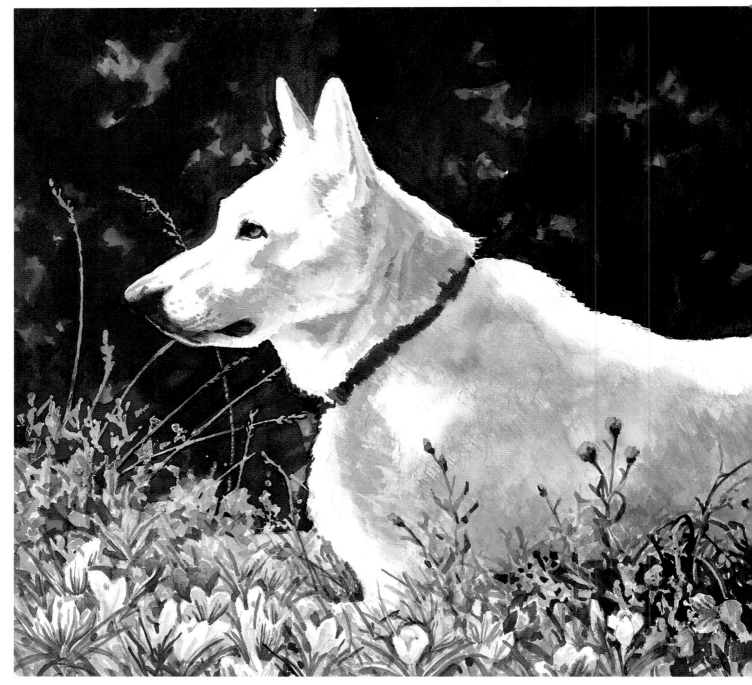

DAKOTA—WHITE SHEPHERD AND SPRING CROCUS
10" x 8" (25cm x 20cm) Watercolor

As seen in the example on the left, painted hair can be further textured by dry brushing it with a flat brush. Stroke it in the direction the hair grows, as indicated by the arrow.

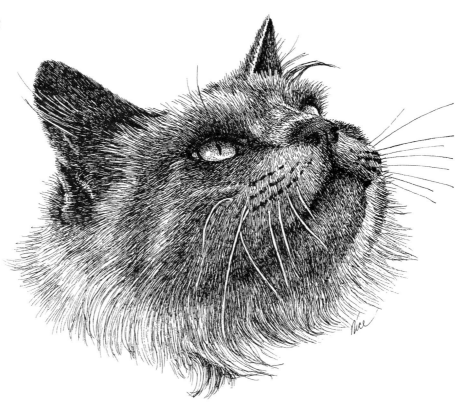

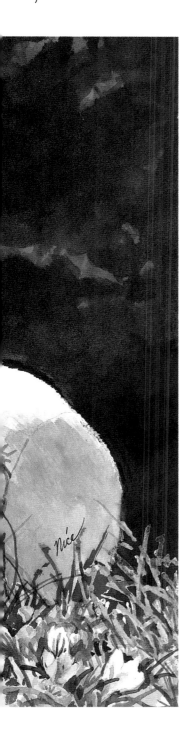

Above is a pen-and-ink portrait of a cat intently watching a butterfly that is just out of sight of the viewer. (nib size .25)

Note how the length of the hair varies. The shortest hairs are around the nose and muzzle (criss-cross lines), and the longest hairs are around the ruff of the neck (wavy lines). It is important that the transition from dark areas of fur to lighter areas of fur be subtle. Abrupt value changes in hair takes away from the soft appearance.

I find the trickiest places in the depiction of fur are the long white hairs or whiskers that cross over patches of darker fur—

I begin by drawing the whiskers with broad pencil strokes. I outline the shadow side with ink. The hair beneath is then stroked in, the ink marks touching both the edge of the pencil and ink shadow lines.

Last of all the pencil is erased.

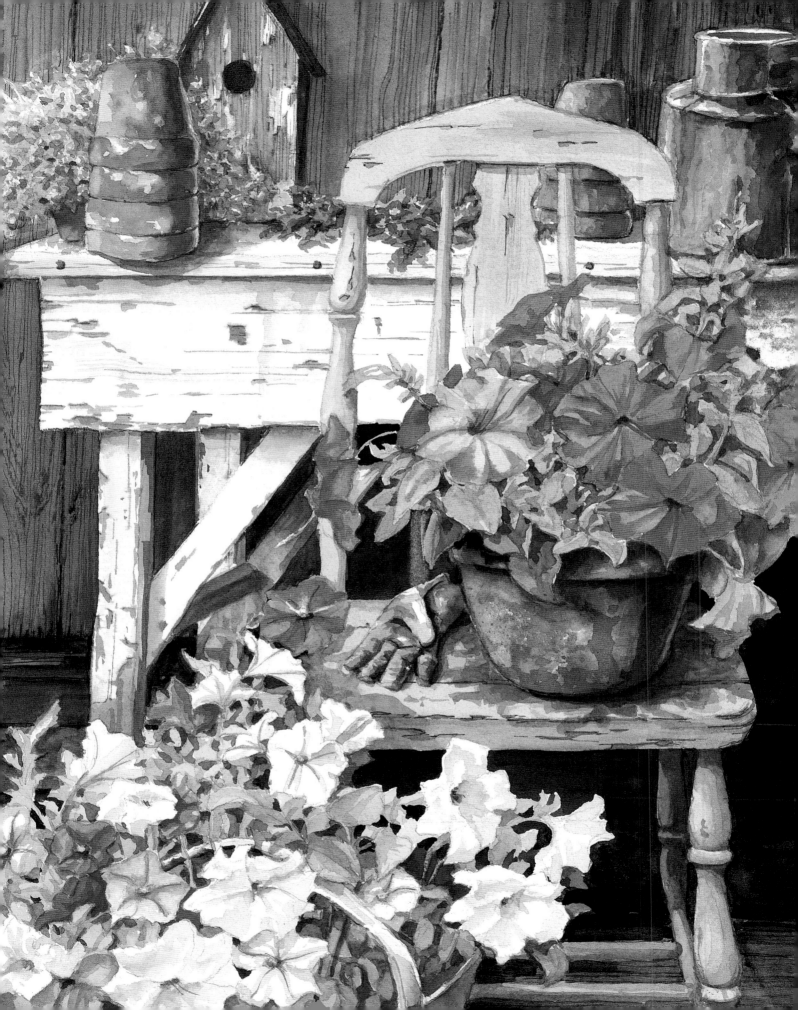

Bright Blossoms and Terra Cotta

Before the age of plastic, Grandma purchased special plants in terra-cotta clay pots. Through the years the pots were recycled to hold herbs, annuals, or whatever she was growing on the porch. Sometimes they became handy holders for gloves, tools or seashells from a vacation at the beach. Terra cotta was never wasted. When it broke, small pieces went into the bottom of other flowerpots to keep the drainage holes open. With use, terra cotta developed earthy smells and wonderful textures. Moss and green algae grew on the damp pots that set in the shade beds. Mineral deposits crusted over the outside of old pots, forming white "blooms." With each crack, battle scar and dirt stain, the pot became more interesting and its nostalgic value increased. Some great old clay relics were passed on to the next generation with a family heirloom plant tucked safely inside. In this way, the plantings and traditions were perpetuated from one country garden to the next.

When I think of terra cotta, I think of summer. I visualize a kaleidoscope of bright floral annuals: zinnias, poppies, marigolds and petunias in vibrant array. Like gaudily costumed circus performers, the shocking riot of floral hues seems perfectly acceptable—even desirable—when placed together within the clay ring of the terra-cotta pot.

This chapter celebrates the vivid blooms of the annual bedding plants, the tradition of the earthy terra cotta and nostalgic joy of summer in Grandma's garden. May it kindle some bright summer memories of your own.

PETUNIAS IN THE POTTING SHED
8" x 10" (20cm x 25cm) Watercolor with some pen blending to texture the woodgrain in the background

Depicting a Terra-Cotta Pot

Unglazed terra cotta has a matte finish. There will be lots of local color, but no strong white highlights.

Below are some color mixtures that work quite well. Burnt Sienna (B.S.) is the base color.

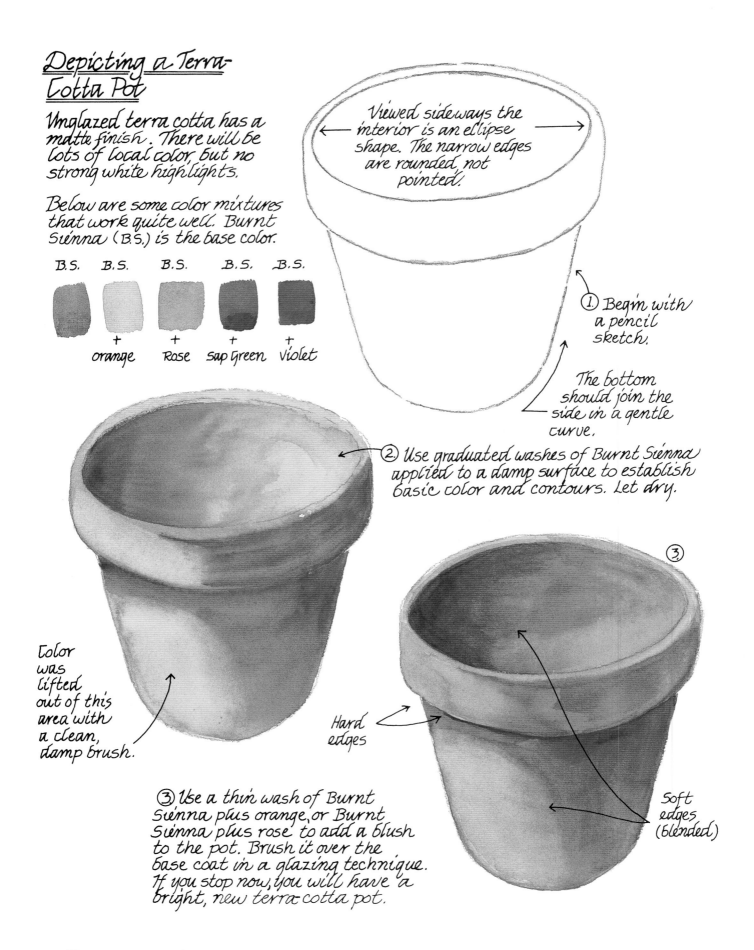

B.S.

B.S. + orange

B.S. + Rose

B.S. + Sap Green

B.S. + Violet

Viewed sideways the interior is an ellipse shape. The narrow edges are rounded, not pointed.

① Begin with a pencil sketch.

The bottom should join the side in a gentle curve.

② Use graduated washes of Burnt Sienna applied to a damp surface to establish basic color and contours. Let dry.

③

Color was lifted out of this area with a clean, damp brush.

Hard edges

Soft edges (blended)

③ Use a thin wash of Burnt Sienna plus orange, or Burnt Sienna plus rose to add a blush to the pot. Brush it over the base coat in a glazing technique. If you stop now, you will have a bright, new terra-cotta pot.

④ To depict a used flower pot, darken the shadows and create a few stains with glazes of Burnt Sienna plus Sap Green or Violet. Dirt stains often have hard edges.

Spatter

⑤

Dirt stains

razor scrape

⑤ For a truly aged look, add a smudge of algae (Burnt Sienna with more Sap Green added), spatter on some dirt (Sepia) and scrape on a bloom of white with a razor blade. Use Sepia or black ink and pen blend in a crack or two.

Pen blending and patch of algae

Contour lines

This weathered pot was sketched using a sepia sketch pen and a .25 Rapido-graph filled with Sepia ink.

Sepia watercolor wash

63

Light and Bright Florals

Annual bedding plants often come in bright pastel hues. The trick in depicting them is to paint vibrant color, keep it delicate and avoid creating neon mud in the process. Here are the steps.

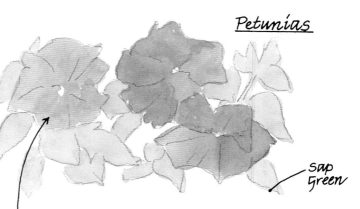

sap green

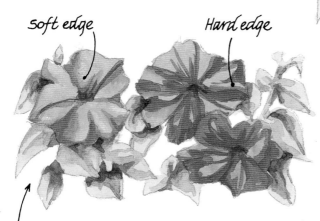

soft edge Hard edge

① Begin with the palest tint seen in the blossoms. Choose from the pure, rich hues found on the outer ring of the color wheel, in this case cool rose red. Thin it to a light shade of pink.

② Continue with the chosen color, using glazing techniques to develope the contours and details of the petunia blossoms. Each layer added should increase in intensity and decrease in the amount of space covered. Use complementary color mixtures to paint the shadowy recess in the center of each petunia and to shape the leaves.

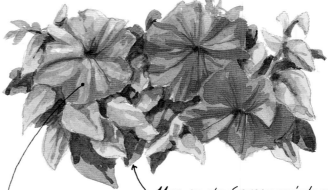

Use muted green mixtures and darker tones to fill in the background foliage.

Cool glaze

Warm glaze

Base color

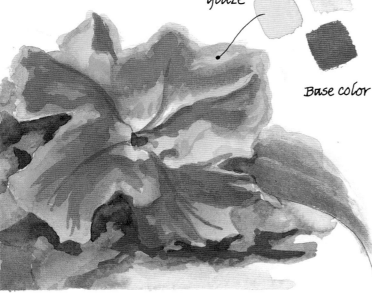

③ You can change the "temperature" of the flowers and add an iridescent quality to the petals by adding an analogous glaze. Analogous colors are those that are adjacent on the color wheel. To the cool side of rose red are the violets. To the warm side are the reddish oranges. Choose one, depending on the overall color scheme of your composition and how you want the temperature of the flowers effected. Thin the analogous color to a pale lavendar or peach wash and lightly glaze the petals. Note the effect on the two examples. Zing!

White becomes bright when contrasted against a dark background. In the pen and ink drawing of the hibiscus blossoms (right), the white highlighted petals pop right out of the black areas.

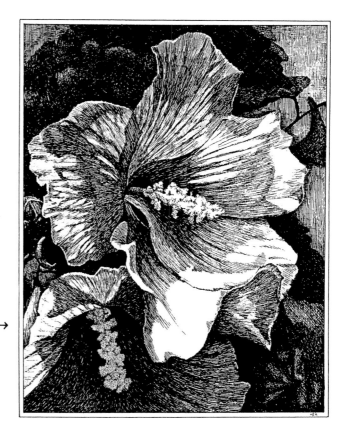

The original size of this floral ink study is 8x10 inches. Contour lines were used to detail the petals, dots were used on the style and the background was crosshatched. Pen sizes .25 & .50. →

The painted display of sweet peas (below) is a good example of how well analogous colors work together. Their brightness is tempered by the gray weathered wood behind them.

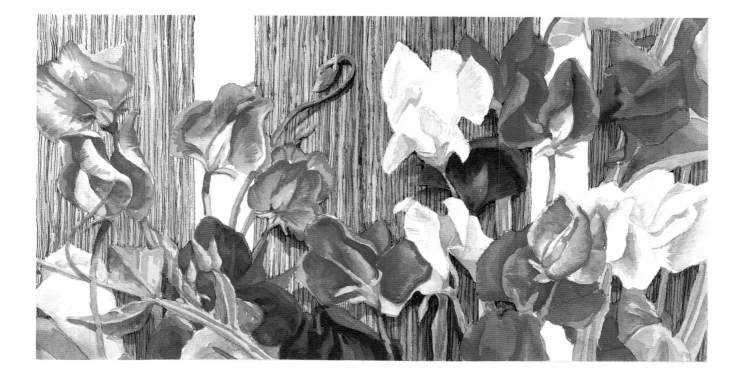

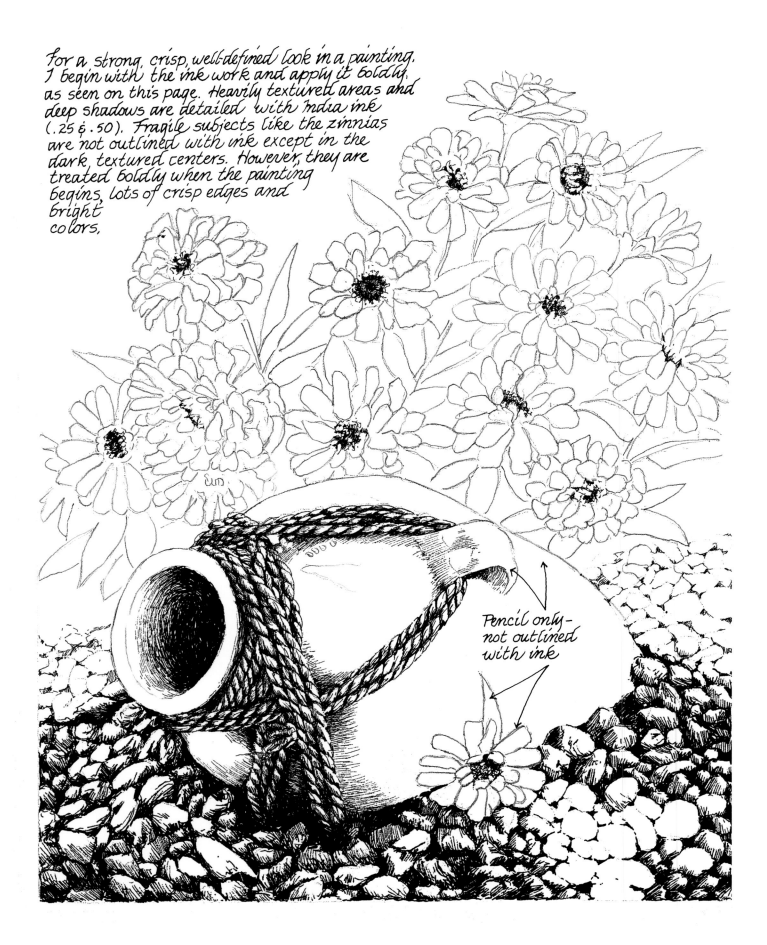

For a strong, crisp, well-defined look in a painting, I begin with the ink work and apply it boldly, as seen on this page. Heavily textured areas and deep shadows are detailed with India ink (.25 & .50). Fragile subjects like the zinnias are not outlined with ink except in the dark, textured centers. However, they are treated boldly when the painting begins, lots of crisp edges and bright colors,

Pencil only—not outlined with ink

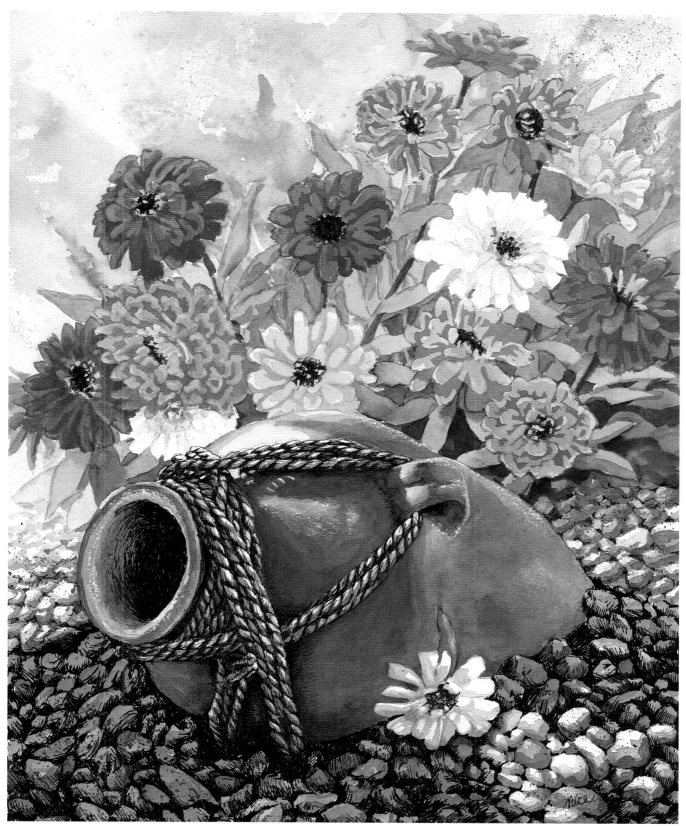

ZINNIAS AND CLAY JAR
8" x 10" (20cm x 25cm) Pen and ink, watercolor

Bold and Bright Florals

Masking fluid and bright colors were used to give these flowers their vibrancy. The crisp edges seem to pop them right out from the background.

warm red plus cool red

rose

Zinnias

① Make a preliminary pencil drawing and darken the centers with India ink.

② Block the colors in boldly and let dry. Mask out the areas to remain lighter in value. Let the masking fluid dry.

③ Add a darker wash to the petals. Let the second wash thoroughly dry. Remove the masking fluid. Some of the original wash will be lifted away also, leaving light, bright petal edges.

Masked area

④ Soften harsh edges within the zinnias with glazes of the original color. Use a clean, damp brush to blend as needed.

3.

4.

Poppies

A. Pencil-sketch the flowers, stems and pods. Mask them out, let the masking fluid dry, and apply the background color and textures.

B. Remove the mask.

Varied green washes

These flowers are farther away than the zinnias. Less detail is required.

C. Paint the flowers, pods and stems.

Crumpled kleenex blot

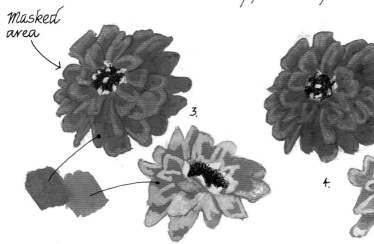

Spatter

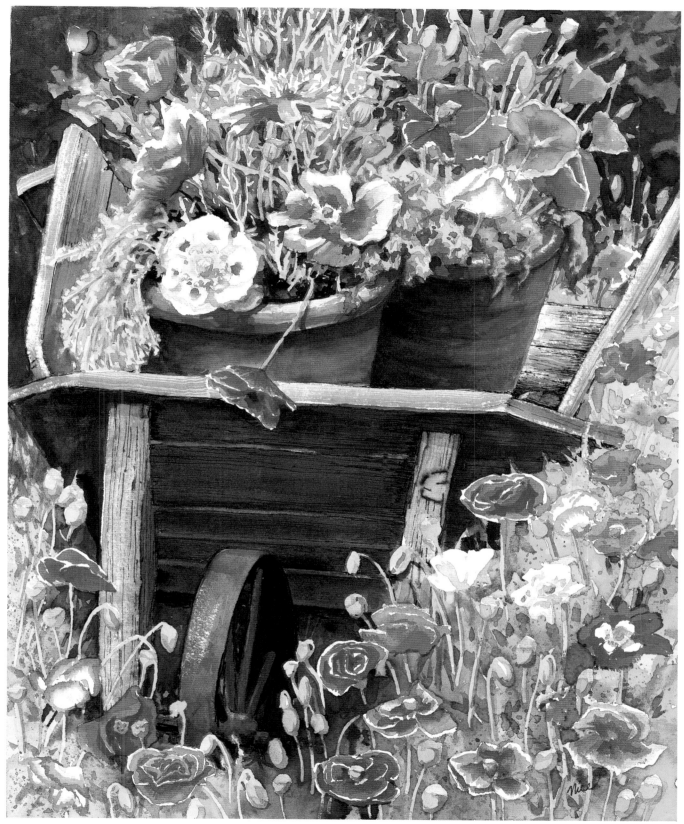

THE POPPY MEADOW
8" x 10" (20cm x 25cm) Watercolor accented with pen blending on the wooden parts of the wheelbarrow

Garden Decorations

Statues have always been favorite garden adornments. They work well for centers of focus, both in the flower bed and in garden landscape paintings.

Quick sketch
(.25 Rapidograph)

Hard lines suggest solid edges.

Water color glazes —

Burnt Sienna, with Sap Green and Sepia added in the deep shadow areas.

Age the statue with a wash of Sap Green near the base to suggest algae.

Spatter

In the old-fashioned garden, statues of animals, children, mythical fairy folk and religious figures were, and still are, the most popular. The terra cotta winged cherub depicted on this page resides in my own flower bed.

Ground shadows are important to anchor heavy objects in place.

70

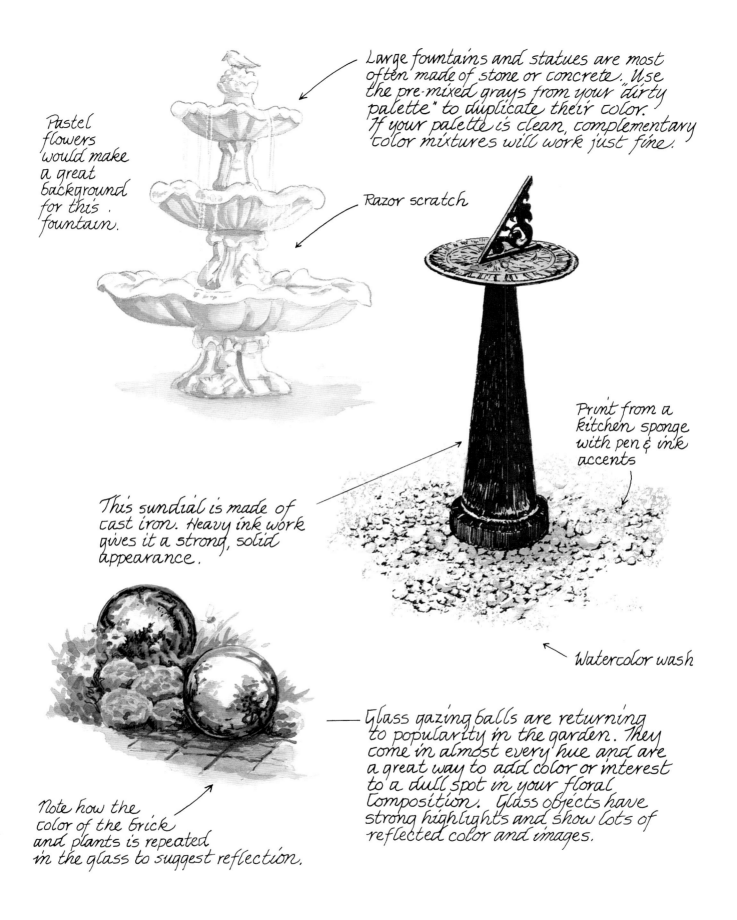

Pastel flowers would make a great background for this fountain.

Large fountains and statues are most often made of stone or concrete. Use the pre-mixed grays from your "dirty palette" to duplicate their color. If your palette is clean, complementary color mixtures will work just fine.

Razor scratch

Print from a kitchen sponge with pen & ink accents

This sundial is made of cast iron. Heavy ink work gives it a strong, solid appearance.

Watercolor wash

Note how the color of the brick and plants is repeated in the glass to suggest reflection.

Glass gazing balls are returning to popularity in the garden. They come in almost every hue and are a great way to add color or interest to a dull spot in your floral composition. Glass objects have strong highlights and show lots of reflected color and images.

The Birdbath

Birdsong and the glint of sunlight in water is as important to the country garden as the flowers grown there. The birdbath provides a way to have both. The ink studies on this page are examples of ornate Victorian birdbaths, but simple ones will attract just as many birds.

Sepia Ink

In the birdbath painting on the opposite page no pen-and-ink work was used. The flowers and lighter leaves were masked out while layers of watercolor were applied to fill in and texture the background. Wet-on-wet techniques, water drops, spray-misting, spatter, kleenex blotting and brush tip printing were all employed to help give the flower bed the look of reality. Note how important white areas become when a composition is this busy.

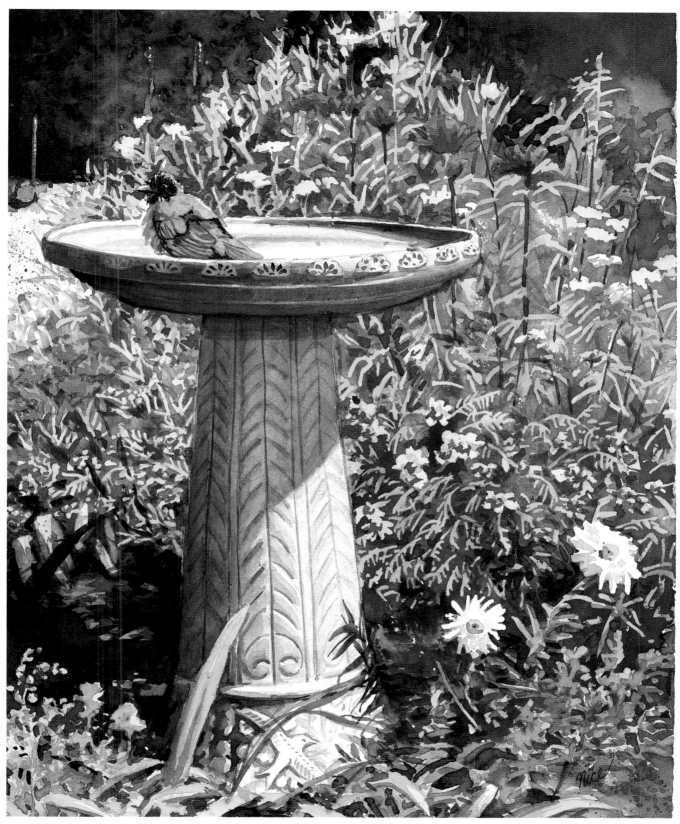

BIRDBATH, MARIGOLDS AND DAISIES
8" x 10" (20cm x 25cm) Watercolor

Building a Brick Wall

Brick is the first cousin of Terra Cotta. It's often rougher in texture, but has the same warm coloration, ranging from muted yellow orange through reddish brown shades to deep maroon. The occasional white or black brick can be thrown in for variety. An aged brick wall makes a wonderful background for a garden scene. Here's how to build one with brush and pen.

① Pencil in the brick shapes. Pencil guide lines will help keep them straight. Stagger the bricks in the rows.

② Use "dirty palette" grays or complementry color mixtures and paint the mortar.

③ Block in the bricks using a variety of Burnt Sienna based color mixtures.

④ Use dry brushing and fine spatter to add details and texture.

⑤ Pen blend India Ink into the shadow areas of the mortar and Sepia Ink into the bricks.

A ¼ inch stroke or flat brush is perfect for painting bricks this size.

Distant brick walls are easier to depict —

Ⓐ Begin with a pencil grid to help maintain proper perspective, evenness and spacing. Really old walls may have broken bricks and sag here and there.

Ⓑ Use complementry gray mixtures and base coat the wall with a pale flat wash. I chose a muted olive green because it complements red and looks mossy.

Ⓒ When the flat wash representing the mortar is dry, paint in the bricks. Use a variety of brick color mixtures.

D Use pen blending to darken the mortar crevices below and at the sides of the bricks. This represents the shadows cast by the protruding bricks, so take light direction into consideration.

Sunlight and shadow areas of the brick wall can be depicted by changing the intensity of the colors used to paint the bricks. Sunlit bricks have a faded appearance, while those in heavy shadow should be painted in dark, muted tones.

Pale sunlit side

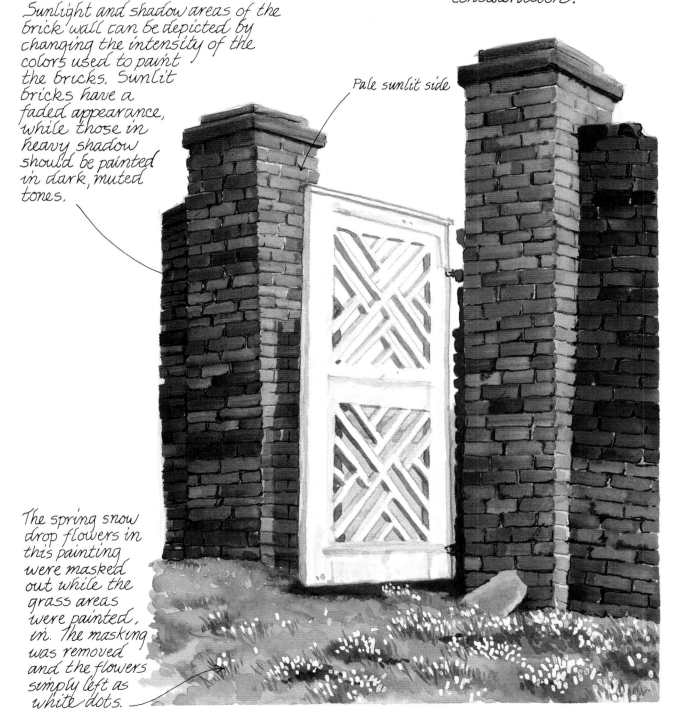

The spring snow drop flowers in this painting were masked out while the grass areas were painted in. The masking was removed and the flowers simply left as white dots.

A Touch of Mystery

Garden scenes should be more than pretty floral landscapes captured on paper. They should invite the viewer to linger, perhaps invoking some nostalgic memories and if possible, inspire a little curiosity. That is where the element of mystery comes in. A feeling of intrigue can be created by shadowy recesses, pathways that curve out of sight or gates and doorways that open into the unknown.

What is behind the open door in the pen-and-ink drawing below? Whatever the imagination of the viewer can dream up!

Note in the painting on the opposite page how the sunlit warmth of the brick and terra cotta invites the viewer into the picture. The smiling face of the wood nymph statue catches the eye, declaring the center of interest. The dark recess beyond the wall not only frames the foreground, but also creates a place of mystery for the curious mind to ponder.

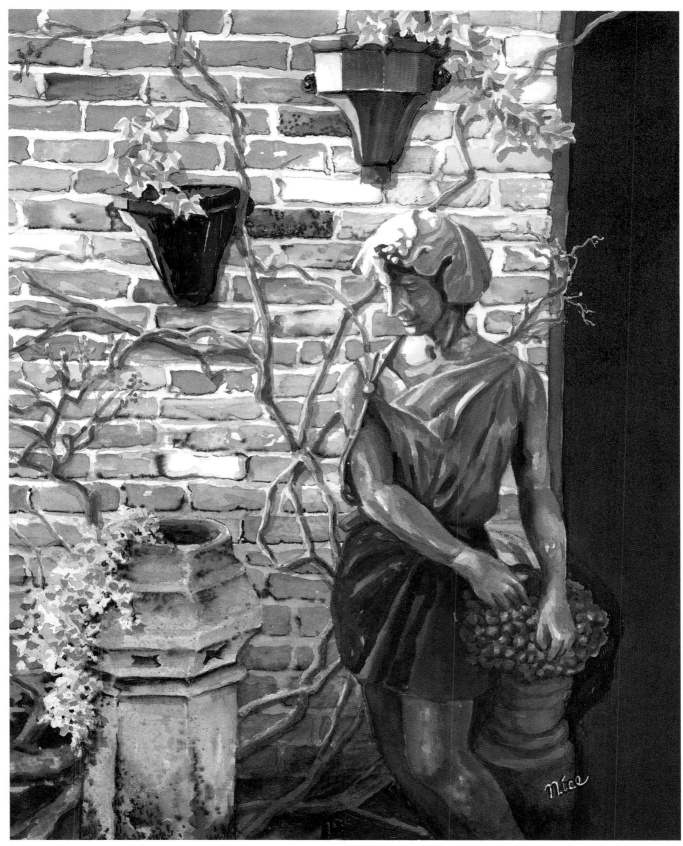

SUNLIGHT ON THE GARDEN WALL
8" x 10" (20cm x 25cm) Watercolor with accents of pen and ink.
India ink was brushed on to create the heavy shadow beside the wall.

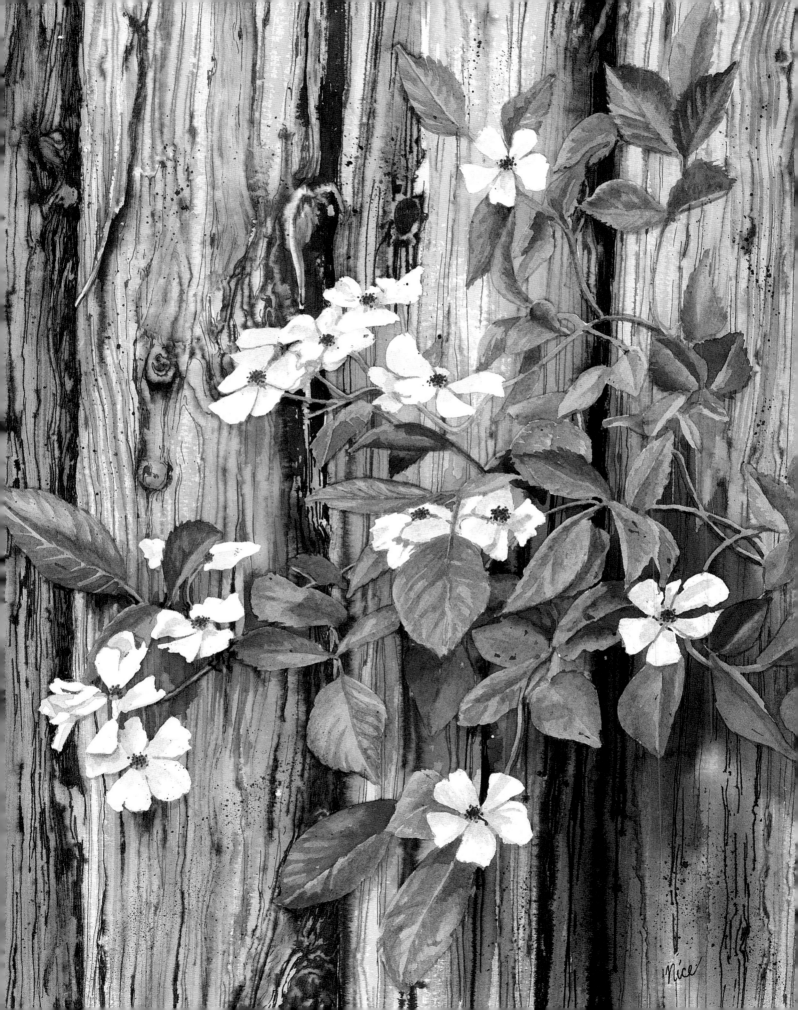

Climbing Vines and Weathered Wood

In your mind's eye, consider a myriad of delicate sun-drenched blossoms and leaves clinging to the rugged surface of aged wood. They form the perfect complement, setting the stage for a dramatic tale or an artistic composition. The wood is sedate, stable and textured with remnants of a past life. If we were creating a play, the weathered board or post would appear as the wizened old mentor. In the artist's composition, it forms a reliable background. Now for the young and vibrant hero of our tale—the vine. It grasps and climbs and twists about, questing for the light like its human counterparts seek truth and knowledge. We find the heroine—maybe more than one—striving with the vine in the form of beautiful delicate blossoms. And of course, our story would not be complete without a little adversity, perhaps in the form of a knothole, a large crack or an area of shadow to confuse and impede the progress of the vine. Our hero and heroine may show signs of their struggle. A blemished leaf or bent petal adds to the reality of the tale. Will they make it to the top of the arbor? Well, that is up to the artistry of the storyteller. In my composition they do! But then, this artist loves happy endings.

There is definitely life and drama in the country garden. Let that be reflected in your scenes of fences, arbors and clinging vines, and you will catch and hold the interest of many a viewer. This chapter is devoted to helping you use contrast of texture, value, color and shapes to achieve vibrancy in your work.

ROUGH WOOD AND WILD ROSES
8" x 10" (20cm x 25cm) Pen and ink, watercolor

Weathered Wood Techniques

① Start with a light varied wash of muted earth tones. Use a flat brush and stroke in the direction of the wood grain. Work quickly so that the resulting washes are a little on the rough side. White, brush-skipped areas will look sunbleached. Let dry. If you need more color, streak on a little more paint, but keep it light. Weathered wood is pale. Scraping a razor blade over the dry wash will give you additional highlights and texture.

Razor blade scrape

Pen blending

Inked wood grain lines (.25)

Add some spattered worm holes.

Heavy crack-pen and ink (.35 or .50)

② Dip a flat brush in a dark wash color, blot the tip, and gently "splay" (separate) the hairs at the tip. Stroke the brush toward you in a continuous motion to create dark wood grain lines. Gently sway the brush for grain variance. This is a dry-brush technique.

③ Use brown, gray, sepia or India ink to add a few darker wood grain lines and details. Follow the pattern already established with the splayed flat brush. Add a light sheen of moisture over the surface and use the pen-blending technique for softer ink lines and spontaneous ink flares.

A knothole, detailed with pen and ink, makes a great point of interest.

Razor blade scrape marks

Spatter

80

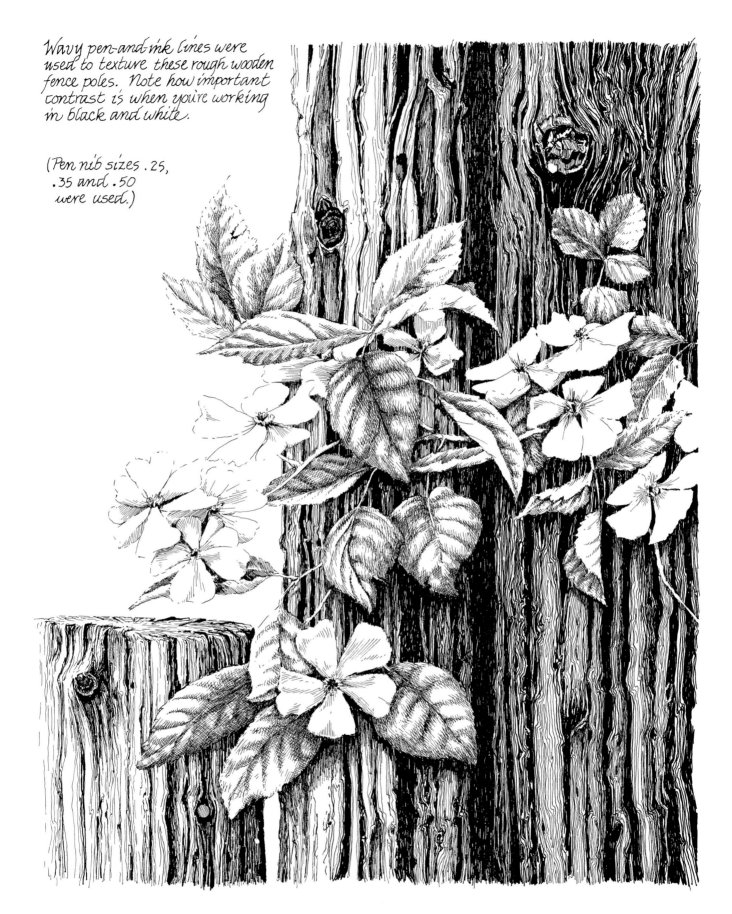

Wavy pen-and-ink lines were
used to texture these rough wooden
fence poles. Note how important
contrast is when you're working
in black and white.

(Pen nib sizes .25,
.35 and .50
were used.)

© Susan Scheewe Publications

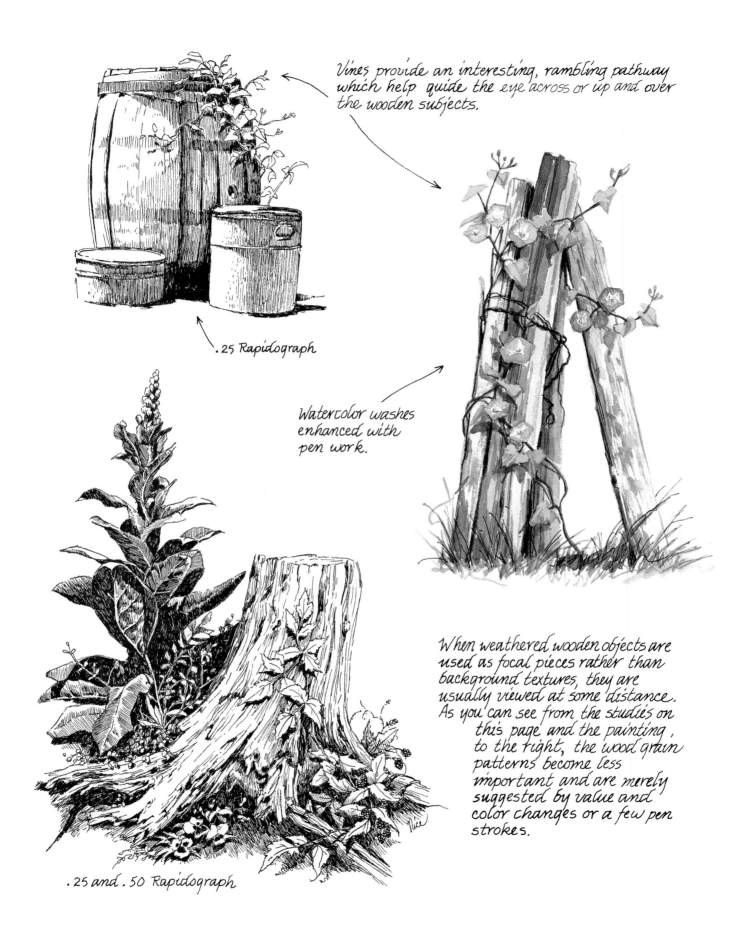

Vines provide an interesting, rambling pathway which help guide the eye across or up and over the wooden subjects.

.25 Rapidograph

Watercolor washes enhanced with pen work.

When weathered wooden objects are used as focal pieces rather than background textures, they are usually viewed at some distance. As you can see from the studies on this page and the painting, to the right, the wood grain patterns become less important and are merely suggested by value and color changes or a few pen strokes.

.25 and .50 Rapidograph

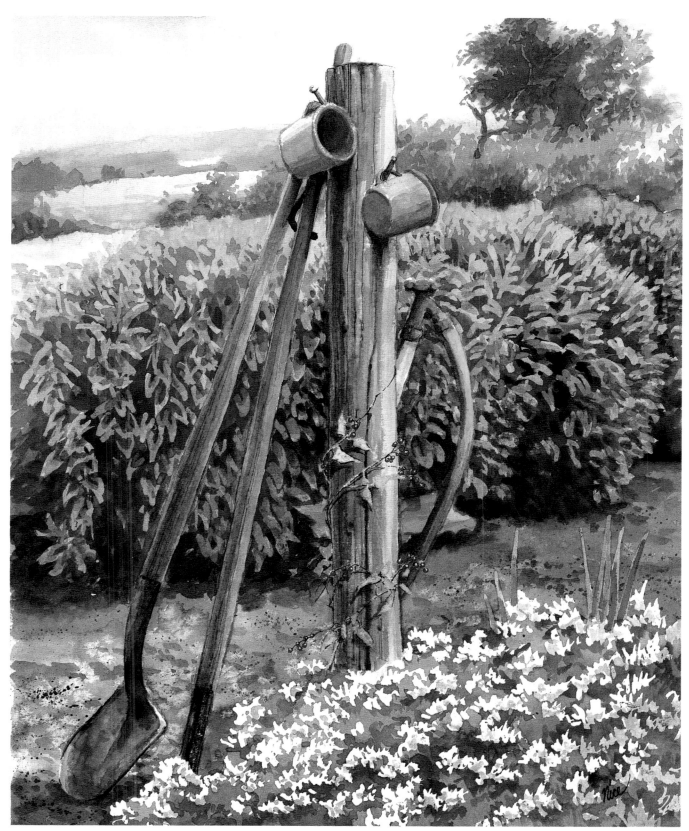

IN CASE OF THIRST
8" x 10" (20cm x 25cm) Watercolor textured with Sepia ink

Portraying Peeling Paint

Any painted wooden object that stays in the garden throughout the seasons will begin to weather, check and flake. Sometimes this adds charm and a great deal of artistic texture. Here's how to capture its character.

① Pencil sketch the general shape of the object, noting cracks and areas of missing paint.

Violet muted with yellow orange.

② Mix two complementary colors to create a neutral gray and lightly shade the contours of the object. Work on a damp surface.

Leave highlighted white areas unpainted

③ Deepen the shadows by glazing on additional layers of paint. Blend the edges on rounded contours and leave hard edges on cast shadows and abrupt folds.

④ Mix Sepia with Payne's gray (cool) or Burnt Sienna (warm), and lightly base-coat bare wood areas. Glaze in shadows where appropriate.

⑤ Use Sepia ink in a .25 Rapidograph and pen blend in the cracks, checks and heavy shadows under lifted paint flakes. Re-moisten the areas as needed with a clean brush.

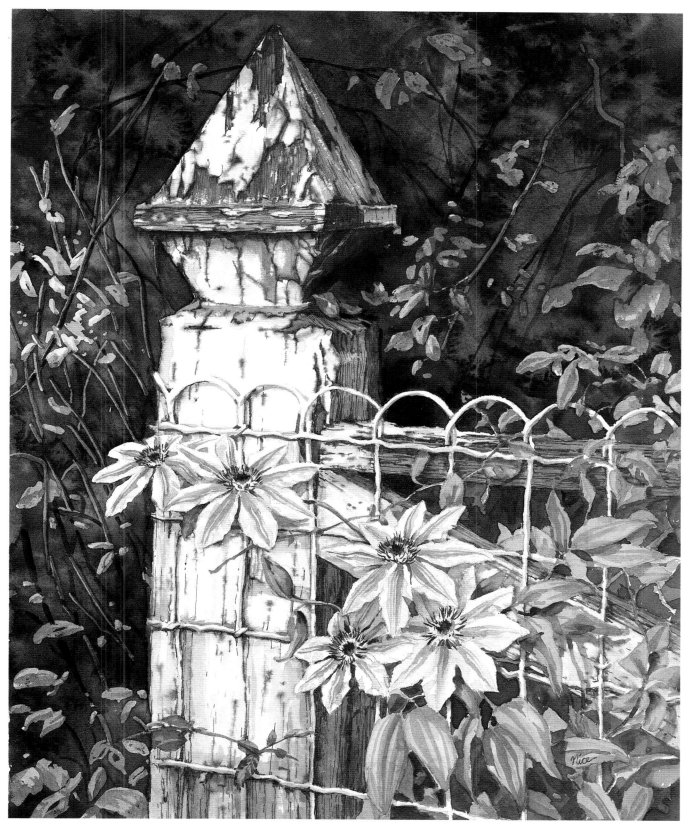

WILD AND OVERGROWN
8" x 10" (20cm x 25cm) Watercolor and Sepia ink work. Pen blending was used on the weathered fence.

Vines and Climbing Plants

Climbing flowers are better appreciated when shown at a distance, so more of the grouping can be seen. Keep them simple, concentrating on the overall effect of the vine. The glazing technique worked well for both step-by-step examples, shown on this page.

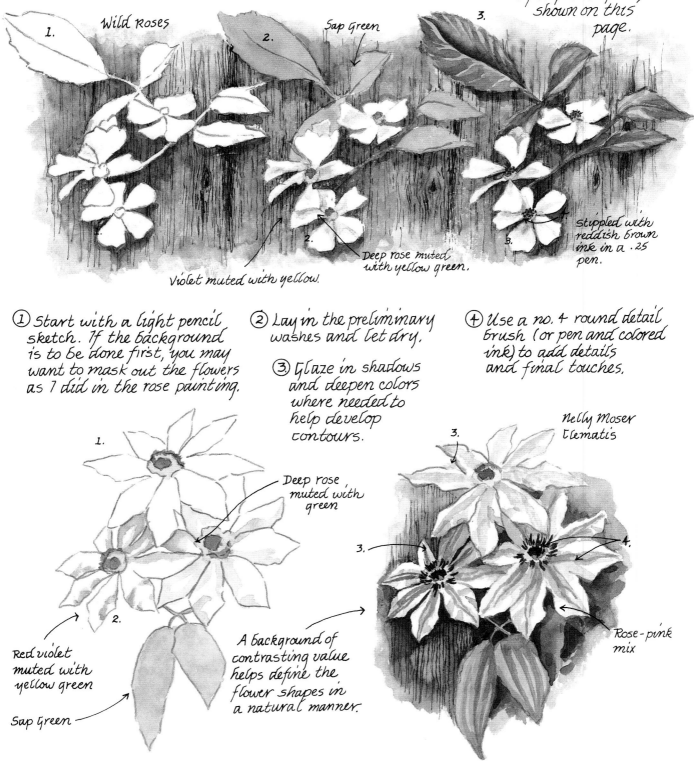

Wild Roses

1.

2.

3.

Sap Green

stippled with reddish brown ink in a .25 pen.

Deep rose muted with yellow green.

Violet muted with yellow.

① Start with a light pencil sketch. If the background is to be done first, you may want to mask out the flowers as I did in the rose painting.

② Lay in the preliminary washes and let dry.

③ Glaze in shadows and deepen colors where needed to help develop contours.

④ Use a no. 4 round detail brush (or pen and colored ink) to add details and final touches.

1.

2.

Deep rose muted with green

Red violet muted with yellow green

Sap Green

A background of contrasting value helps define the flower shapes in a natural manner.

Nelly Moser Clematis

3.

3.

4.

Rose-pink mix

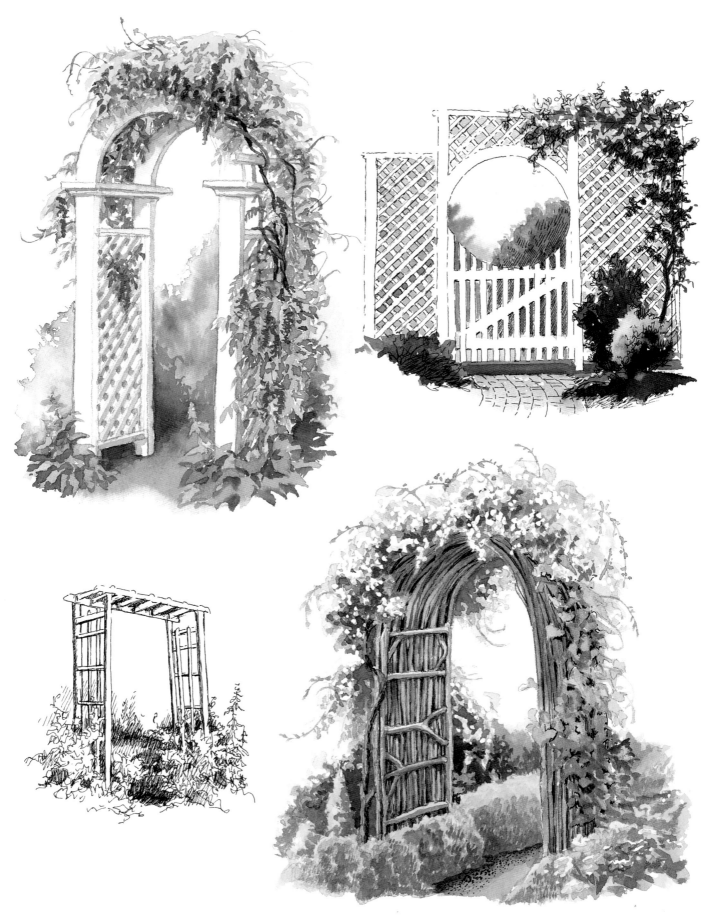

Fences

Fences drawn horizontally across the work surface are not too difficult to sketch, especially if it's a rustic, uneven fence like the one on the right. Precise and proper picket fences take a little more care in the initial pencil lay out. By far the trickiest fence is the one that runs diagonally across the paper and recedes away from the viewer into the distance. Not only do the fence posts shrink in size, but the spacing between posts changes.

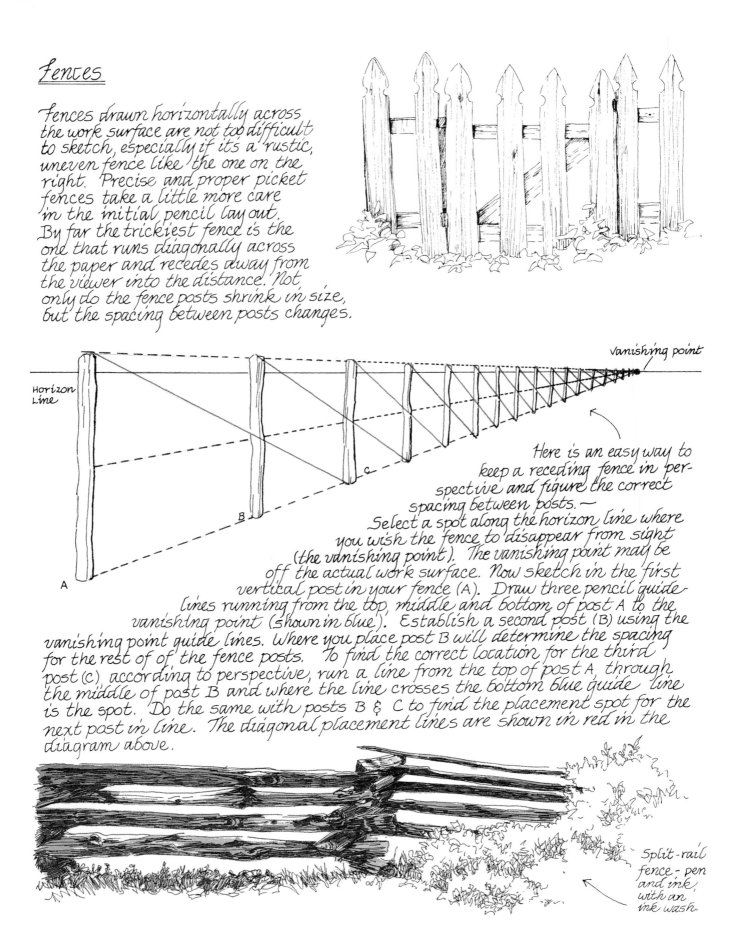

vanishing point

Horizon Line

A

B

C

Here is an easy way to keep a receding fence in perspective and figure the correct spacing between posts. —
Select a spot along the horizon line where you wish the fence to disappear from sight (the vanishing point). The vanishing point may be off the actual work surface. Now sketch in the first vertical post in your fence (A). Draw three pencil guide lines running from the top, middle and bottom of post A to the vanishing point (shown in blue). Establish a second post (B) using the vanishing point guide lines. Where you place post B will determine the spacing for the rest of the fence posts. To find the correct location for the third post (C) according to perspective, run a line from the top of post A, through the middle of post B and where the line crosses the bottom blue guide line is the spot. Do the same with posts B & C to find the placement spot for the next post in line. The diagonal placement lines are shown in red in the diagram above.

Split-rail fence - pen and ink, with an ink wash.

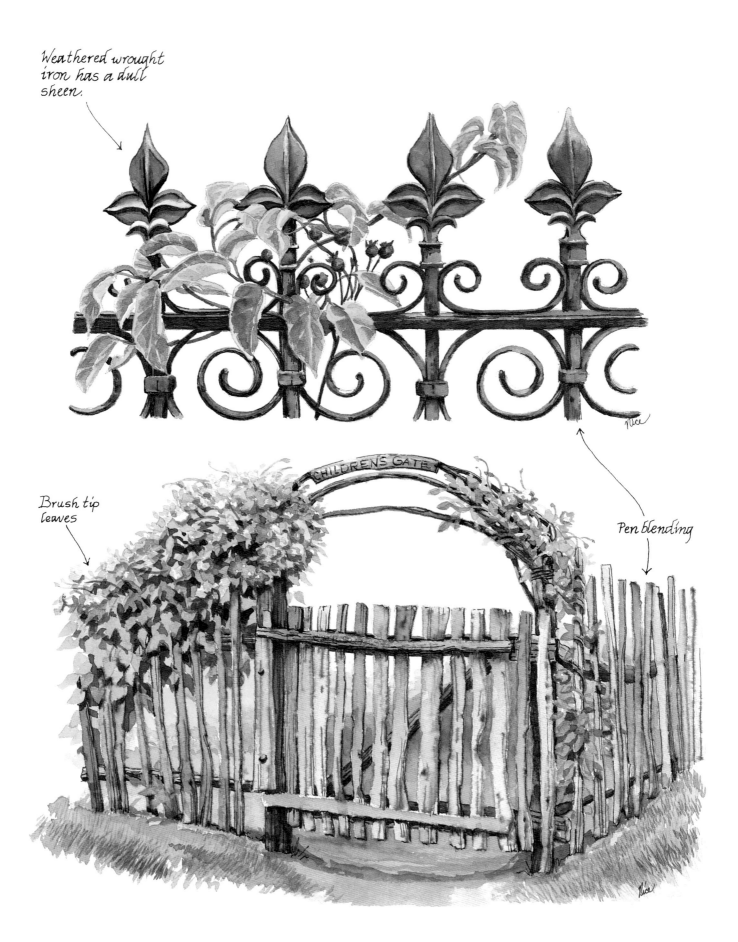

Weathered wrought iron has a dull sheen.

Brush tip leaves

Pen blending

CHILDREN'S GATE

The Picket Fence

The main things to remember in the depiction of a traditional picket fence is to maintain even spacing between the stakes, and to use contrast of color and value as much as possible to form the edges of the posts, rails and pickets.

A plain picket fence

Some examples of fancy picket stakes

In the watercolor sketch below, the spaces between the pickets were painted to form the illusion of a fence. This technique also worked well to suggest the ginger-bread in the roof gable.

Weathered pickets with exaggerated texture provide a fun background for these bright Honeysuckle vines.

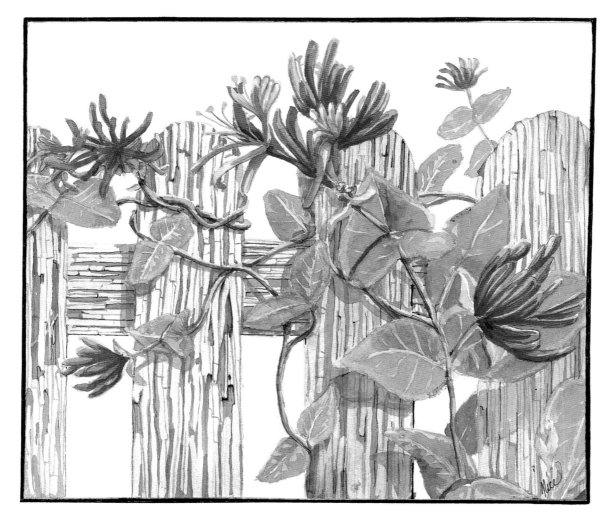

① Tint the posts with a pale wash of Sepia mixed with Payne's Gray. Let dry.

② Mask out vertical strips to resemble paint flakes. Let dry.

③ Add a touch of Ultramarine Blue to the mix and glaze the pickets. Let dry and remove masking.

④ Use a fine detail brush or pen to add fine cracks, and shadows below paint chips.

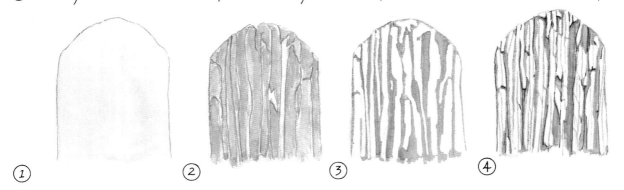

① ② ③ ④

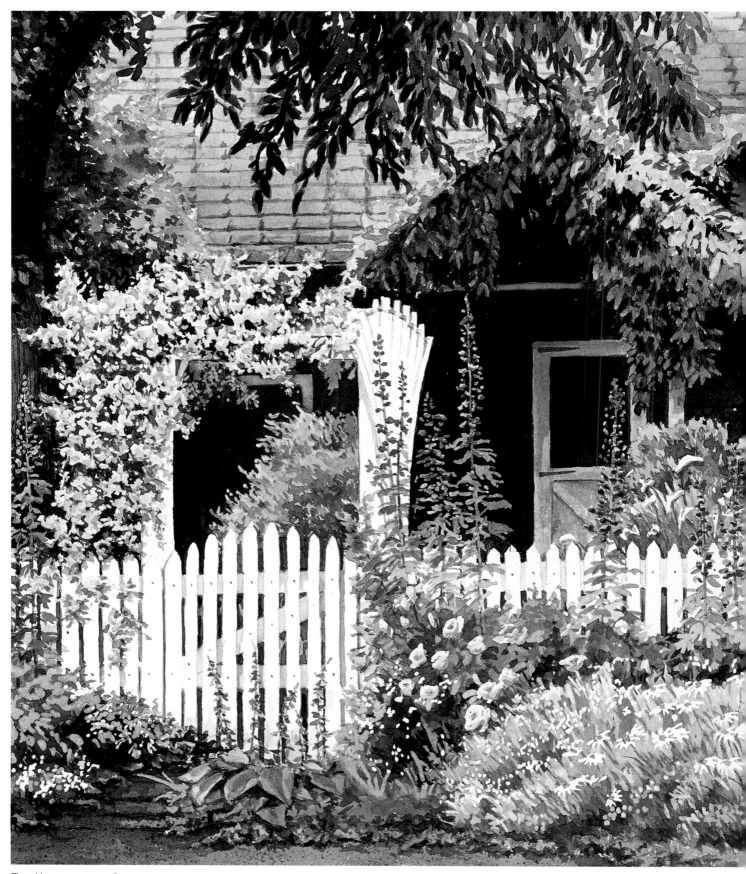

THE VINE-COVERED COTTAGE
18" x 12" (46cm x 31cm) Watercolor

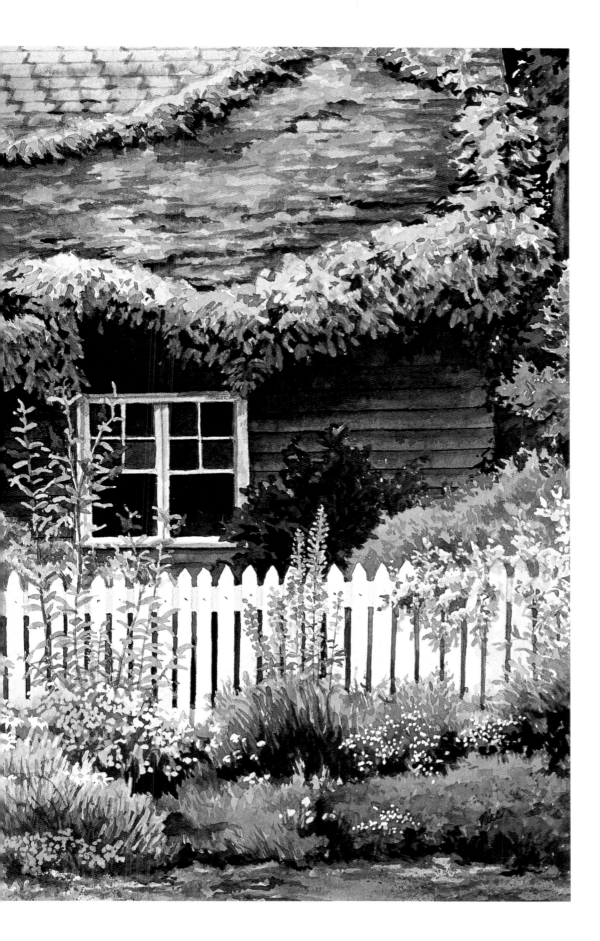

The Vine Covered Cottage

I used a lot of liquid masking fluid in this painting, along with glazing, layering and brush-tip leaves.

Large white areas like the arbor and picket fence were left paper white and the background colors were carefully painted around them. Small white areas like the daisies and tiny baby's breath (dot-like flowers) were protected with a thin layer of liquid frisket.

The florals and lightest-colored foliage clumps were painted with pale basecoats of color, then masked out. Midtones were then painted and in some cases also protected with liquid masking. Note the vine on the roof. I continued to add more glazes and paint layers until the deepest shadow colors had been laid down. This layering/masking technique provides a way to give the painting both sharp, bold contrast and a delicate, airy feel in the garden. A pattern of sunlight seems to run along the fence, up the arbor and across the vines on the roof, providing the eye a circular path to follow. The contrasting deep shadows of the house and overhanging trees add a touch of mystery.

It's such a happy day when a painting comes together as planned and turns out just the way you pictured it in your mind!

This design layout is a 70% reduction of the original size.

Sap Green is the the base color for all the foliage. I used Lemon Yellow, Yellow Ochre and/or Burnt Sienna to warm it. I darkened and cooled it by adding Phthalo Blue Ultramarine and/or Violet.

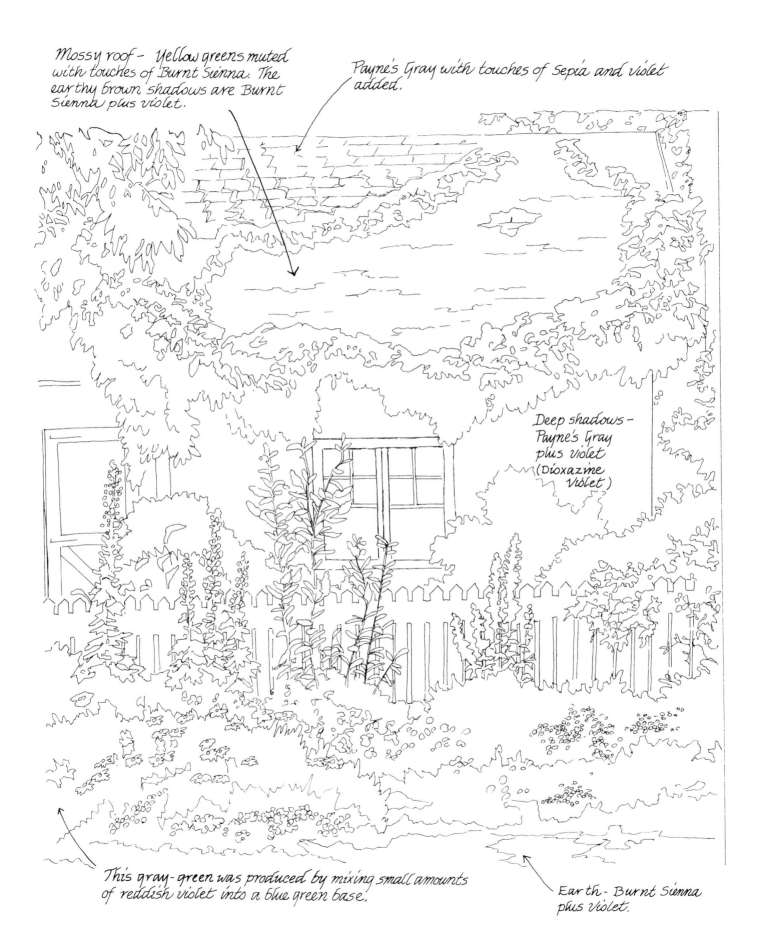

Mossy roof – Yellow greens muted with touches of Burnt Sienna. The earthy brown shadows are Burnt Sienna plus violet.

Payne's Gray with touches of Sepia and violet added.

Deep shadows – Payne's Gray plus violet (Dioxazine Violet)

This gray-green was produced by mixing small amounts of reddish violet into a blue green base.

Earth – Burnt Sienna plus violet.

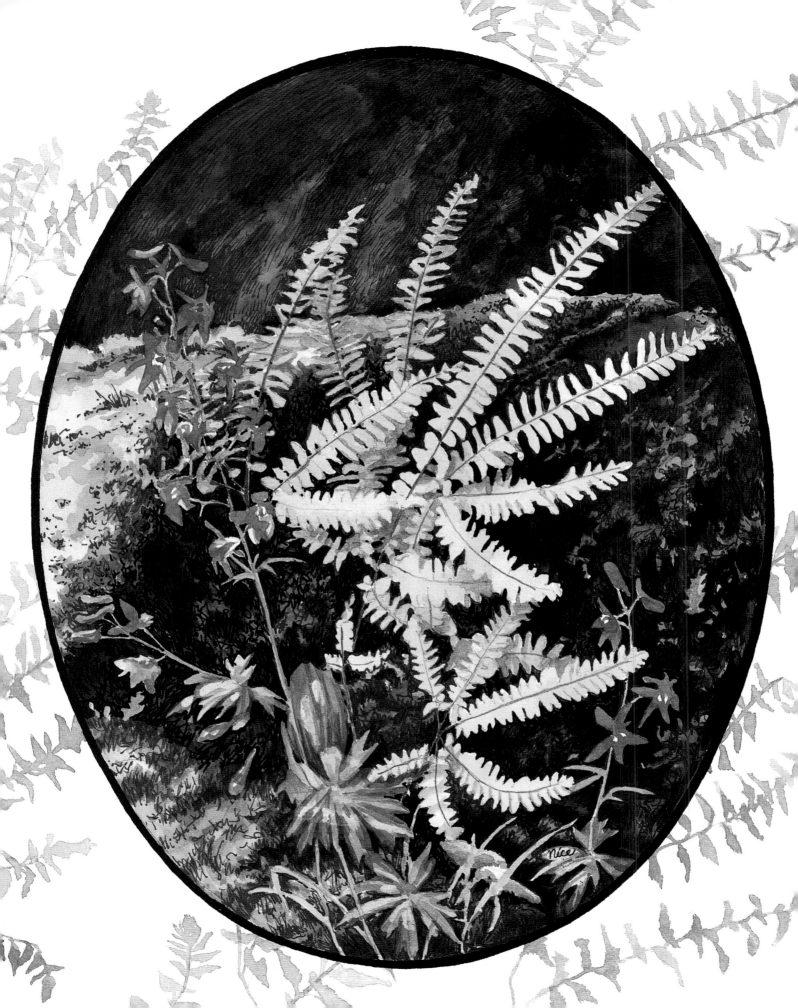

Mossy Stones, Ferns and Shade

The garden shade bed is a place of purple, sepia and blue-gray shadows, cast in the images of leaf and blossom. The passing breeze encourages movement, and the shadow silhouettes sway and dance in rhythmic patterns. The cool serenity is broken here and there by dappled sunlight. Like a spotlight aimed at a darkened stage, the filtered sunrays strike amongst the plants to highlight a delicate fern frond, rest upon a random leaf, or turn a flower petal to electric blue. The deep shadows, contrasted with bits of brilliant light and color, lend drama to the shade bed, and in turn, excite the artist's eye. In depicting such high-contrast scenes, one must keep in mind that the deeper the shadows, the lighter and brighter the sunlit objects of focus need to be. Con-

sider the painting on the opposite page. The pale green fronds of the maidenhair fern come alive against the dark mossy rock background. The same is true of the blue delphinium blossoms. Although painted from the same watercolor wash mixtures, the petals set against the deepest shadow seem the most brilliant.

In this chapter I will show you how to use texturing techniques and combinations of pen and paint to achieve really dark background shadows. You'll see how to make stone walls rough and realistic and how to lend a delicate texture to moss and ferns. And at the end of our walk down these shady pathways, I'll show you how to draw a bench in perspective, where your mind's eye can rest and dream up a few more creative ideas.

DELPHINIUM AND MAIDENHAIR FERN
8" x 10" (20cm x 25cm) Watercolor with Sepia and India ink pen work overlaid on background

Stone Walls and Pathways

Rocks come in a great variety of shapes, colors and textures. They add stability and a certain earthiness to the garden scene. Here are some of my favorite ways of depicting them.

I began this rock wall with a damp surface wash of Payne's Gray mixed with Sepia. I then pleated a length of plastic wrap horizontally in accordian folds and laid it in the wet wash (weighted down), until dry.

Impressed plastic wrap

Pen and ink

Scribble lines applied with a .25 Rapidograph pen.

Watercolor wash, scraped with a blunt tool when almost dry

Mixed media

India ink

Sepia pen blending

Drybrushing

← Sepia pen work

Sketched with a Sepia Nexus pen.

Criss-cross lines ___

Parallel lines ___

The pathway below was painted in watercolor. The stones, flowers and distinct leaves were masked out while the background and soil areas were developed. A very pale wash of Sepia mixed with violet was used to tint the stepping stones. Fine spatter was used to add texture.

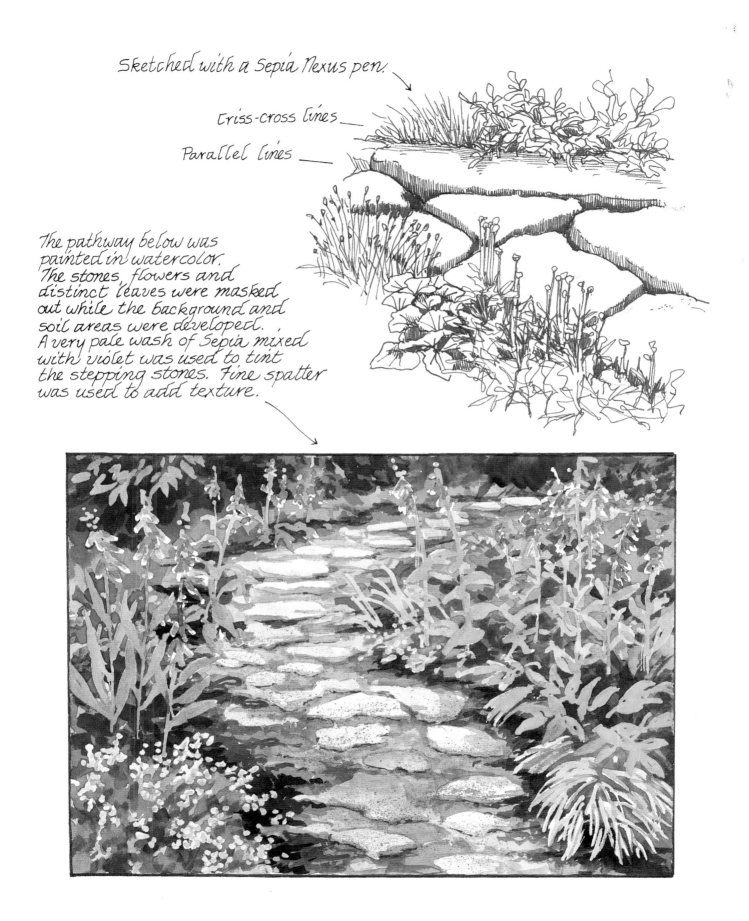

The bricks are so weathered and old in the garden wall painted on the opposite page, that they have taken on the look, texture and patina of stone. To show this, I muted the brick siennas and oranges with a final glaze of blue and blue violets. Dry-brush and pen blending added an aged texture. The flowers in this shady corner garden are Caladium, Clematis and Monk's Hood.

In this airy watercolor mini-ature, the sunny foreground recedes into a deeply shady background. To maintain a soft edged look, liquid frisket was not used. Note how the white stepping stones form a pathway into the composition. This is repeated in the white of the sky, house and flowering vine.

This partially finished sketch of a stone wall and fern bed began with a loose pencil drawing. Value and texture were added with a neutral-toned watercolor wash.

Pen blending

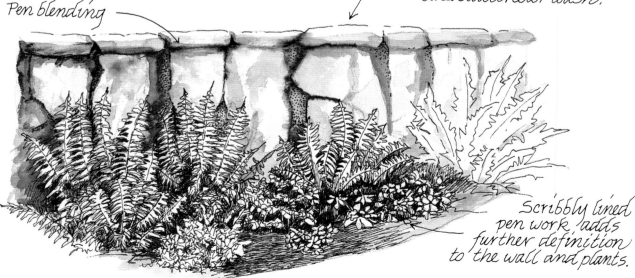

Scribbly lined pen work adds further definition to the wall and plants.

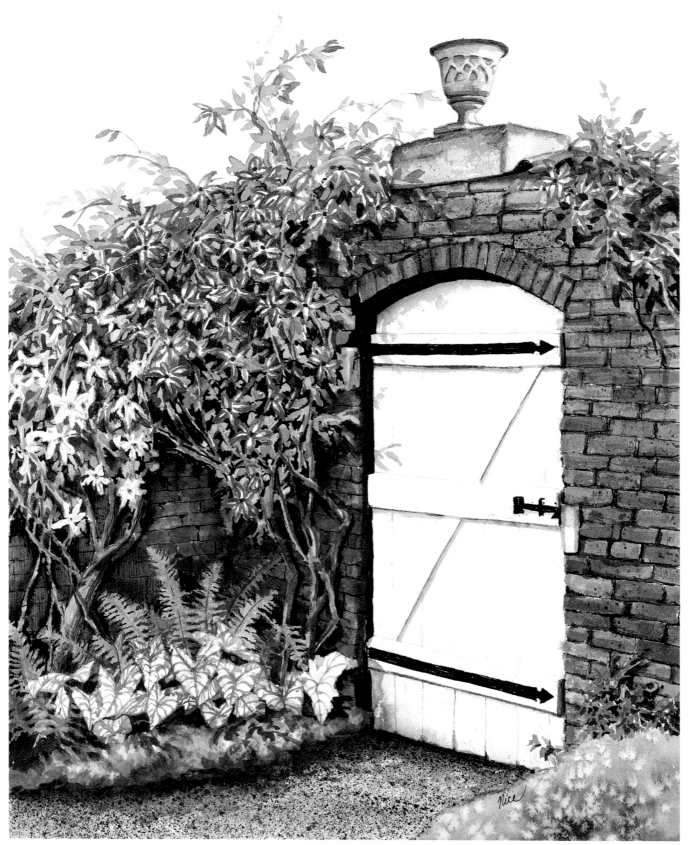

THE SHADY SIDE OF THE WALL
8" x 10" (20cm x 25cm) Watercolor with pen blending

The painting of the mossy stone wall, (opposite page) began with an idea, sketched in pencil.

① I began the painting process by stroking in the Harts-tongue fern and other vegetation. Painting the foliage first helped to establish its location, and to determine how dark the rocks and shadow areas behind it needed to be. ——→

Preliminary pencil outline

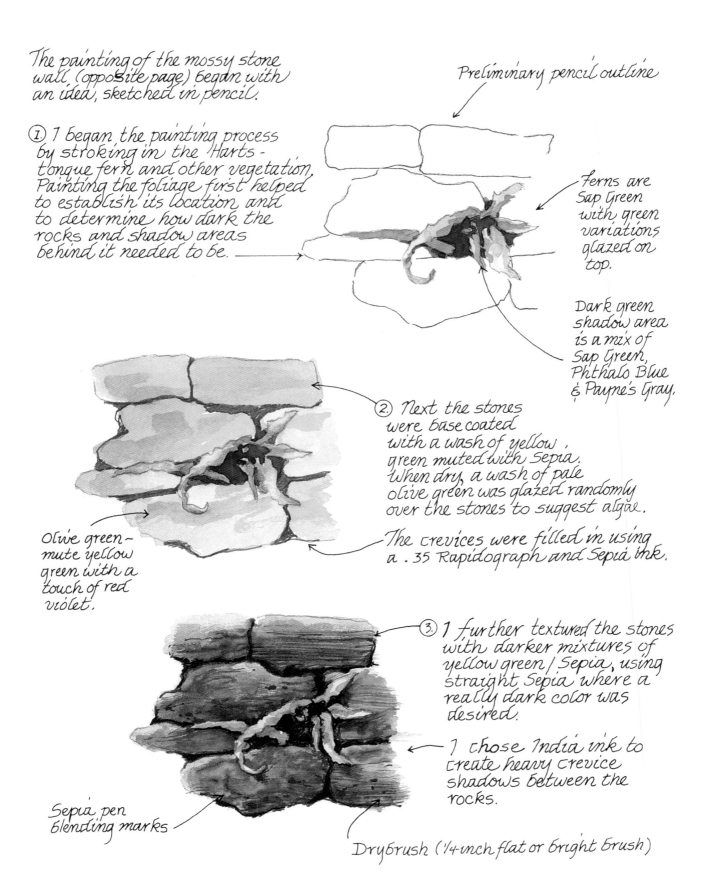

Ferns are Sap Green with green variations glazed on top.

Dark green shadow area is a mix of Sap Green, Phthalo Blue & Payne's Gray.

② Next the stones were base coated with a wash of yellow green muted with Sepia. When dry, a wash of pale olive green was glazed randomly over the stones to suggest algae.

The crevices were filled in using a .35 Rapidograph and Sepia ink.

Olive green – mute yellow green with a touch of red violet.

③ I further textured the stones with darker mixtures of yellow green/Sepia, using straight Sepia where a really dark color was desired.

I chose India ink to create heavy crevice shadows between the rocks.

Sepia pen blending marks

Drybrush (¼-inch flat or bright brush)

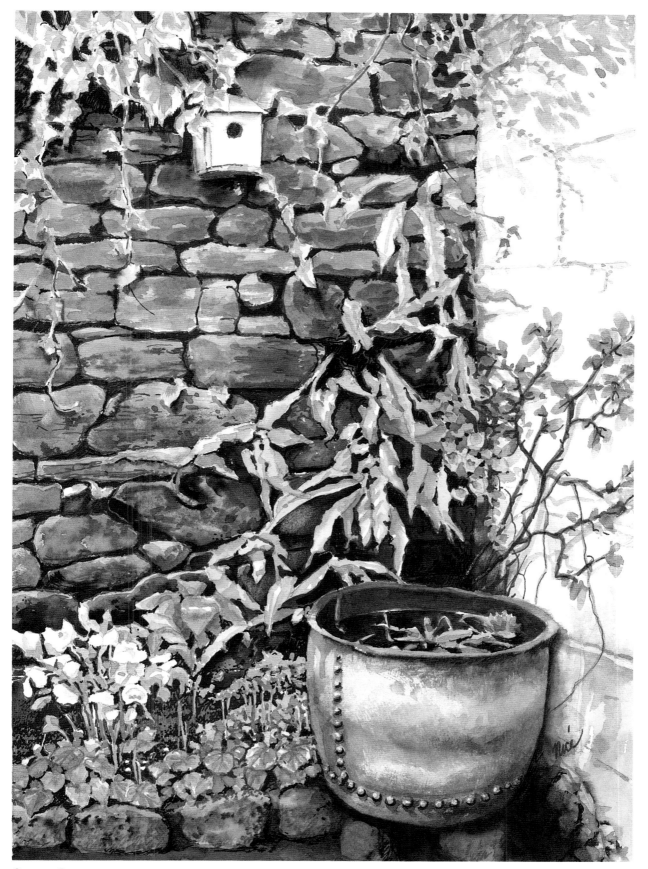

CORNER GARDEN
7" x 10" (18cm x 25cm) Watercolor textured with pen blending in India and Sepia ink

Moss

Walk any well-established shade garden pathway and you will most likely come across moss. It provides a great contrast to the rough, hardness of stone. It's one of my favorite textures to paint and actually easy.

① Start with a dry surface, varied wash of yellow green and pale olive green. Spritz the edges with a spray (water) bottle to form "lace."

Sepia pen work

② While the first wash is damp (not wet), gently pat in a second layer of color. I added Burnt Sienna and Sap Green above. Let the two layers run together and mingle freely. Do not over-brush! While the wash is still moist, sprinkle in table salt. Let the wash dry completely before brushing off the salt.

Brush work

③ Darken shadow areas with criss-cross strokes, and either a pen or a fine, round detail brush.

This distant clump of moss started out with a damp surface wash of yellow green. (The edges were softened with a dab of a kleenex). The darker green texturing was stamped over the dry base-wash using a moist sea sponge.

Both the salt technique and the
sea sponge technique were used to
depict the moss in the garden
scene below. The flowers in the
foreground were masked out
while the moss textures were
being developed.

The dark green background was enhanced
further with an overlay of dark green
pen work. Note how the green stippling helps
to soften the area where the foreground and
background meet.

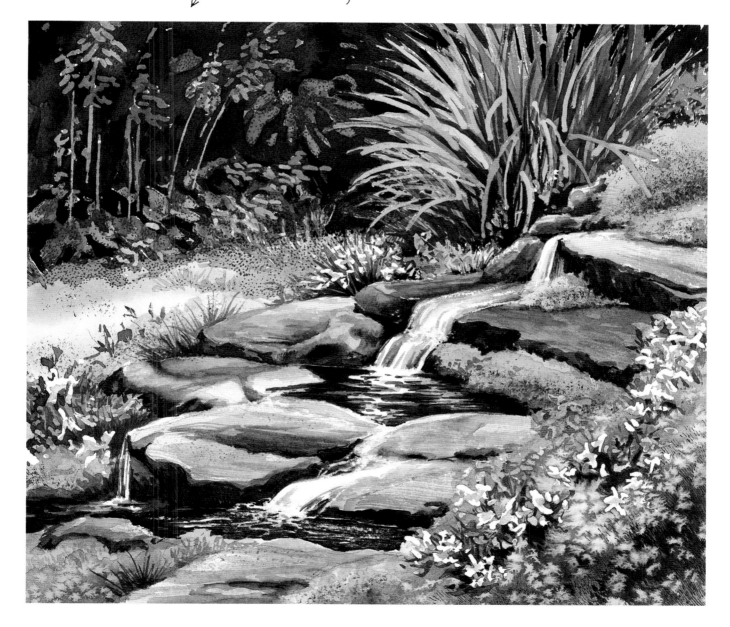

Ferns

Ferns

Ferns are the "lace trim" of the shade garden. To depict them, begin by defining their basic structure (A). Then pencil in the shape of the individual leaflets (B). With the form laid out, the fern is then ready to paint or detail with pen and ink (C).

Ⓐ Ⓑ Ⓒ

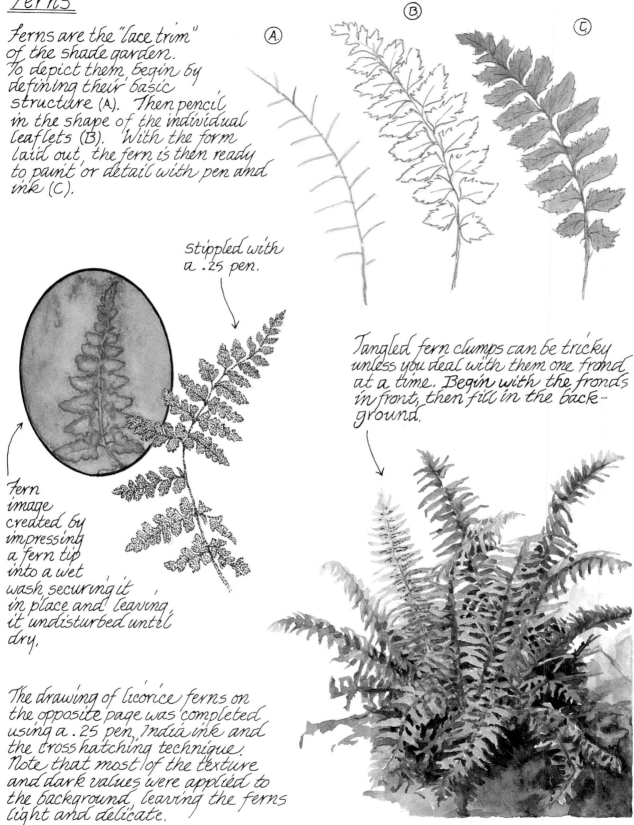

stippled with a .25 pen.

Fern image created by impressing a fern tip into a wet wash securing it in place and leaving it undisturbed until dry.

Tangled fern clumps can be tricky unless you deal with them one frond at a time. Begin with the fronds in front, then fill in the background.

The drawing of licorice ferns on the opposite page was completed using a .25 pen, India ink and the cross hatching technique. Note that most of the texture and dark values were applied to the background, leaving the ferns light and delicate.

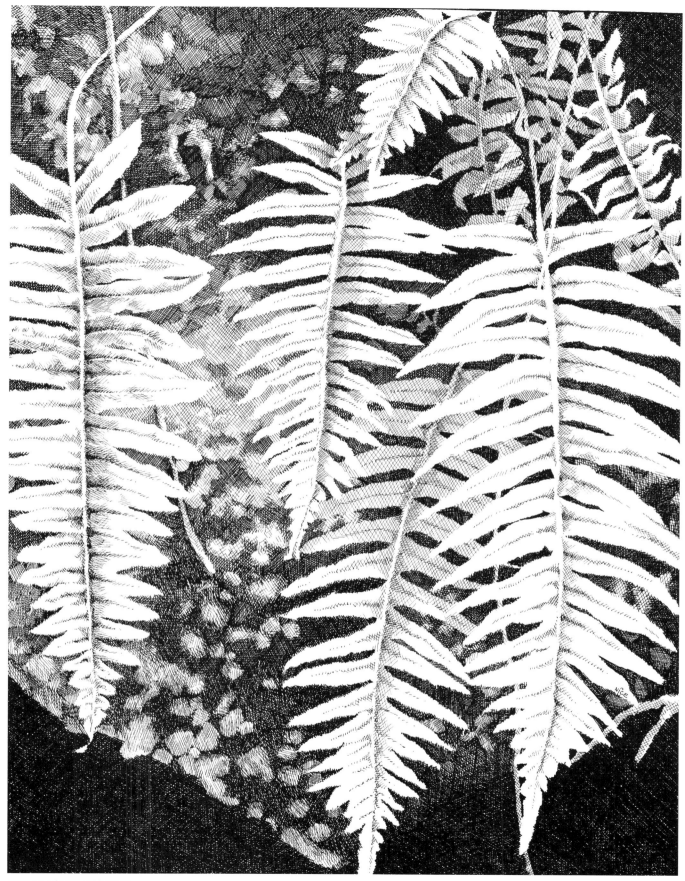

© Susan Scheewe Publications

Ferns that are part of a larger landscape need not be very detailed. Shape and color will usually suggest them well enough. A contrasting background will help define their contours.

Note the ferns in the foreground of the garden gate painting (opposite page). Masking fluid was used to protect them while the dark sepia background was applied.

Below are some basic fern shapes to practice and perhaps work into some of your own garden scenes.

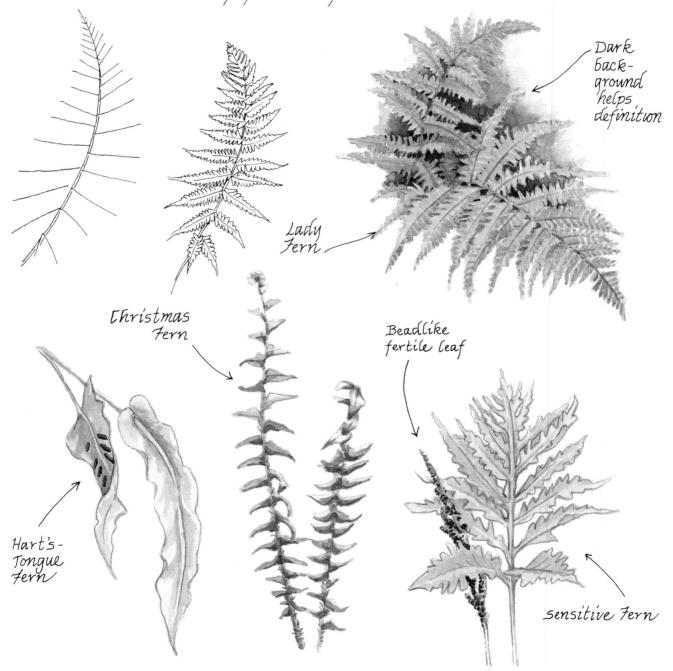

Dark back-ground helps definition

Lady Fern

Christmas Fern

Beadlike fertile leaf

Hart's-Tongue Fern

sensitive Fern

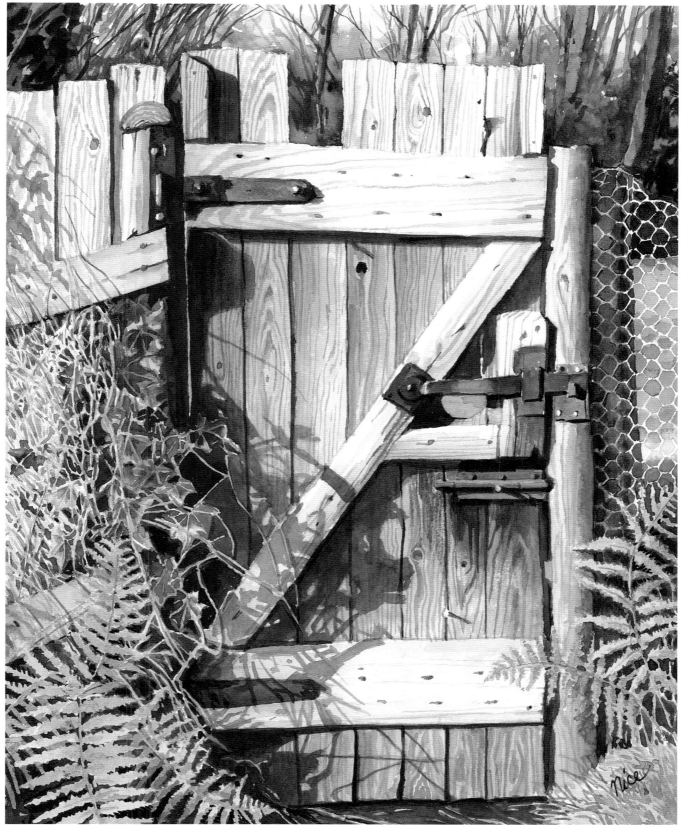

SHADOWS ON THE GARDEN GATE
8" x 10" (20cm x 25cm) Watercolor

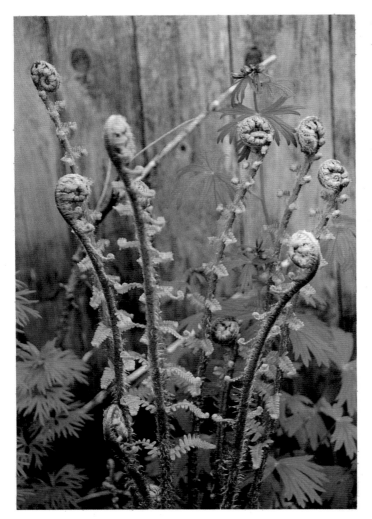

This photo of young Ostrich ferns was taken in my shady fern garden. It is the basis for the whimsical fiddle head painting seen on the opposite page. Just for fun I have painted a myriad of bugs in the foliage...
Including—

Three lady bugs
A June beetle
A honey bee
A cricket
A praying mantis
A lace wing
An earwig
A may fly
An inch worm
A wooly bear cater-
pillar

Although a garden with this many insects on one plant has a problem, the addition of one or two in your close-up floral studies can add a fun touch of reality to your work.

As you can see in the painted version, I opened up the background by removing the non-fern foliage and the wooden fence. The white background gave me the sense of light and space I was looking for, to go along with the fanciful mood I was trying to create.

To help fill in the foliage I added some "fiddle head prints." This was done by painting an actual curled-up fern with Burnt Sienna watercolor paint and pressing it to the paper surface with a paper towel. Rubbing gently across the paper towel helped to tranfer the image. When it was dry, I enhanced it with a pale green glaze.

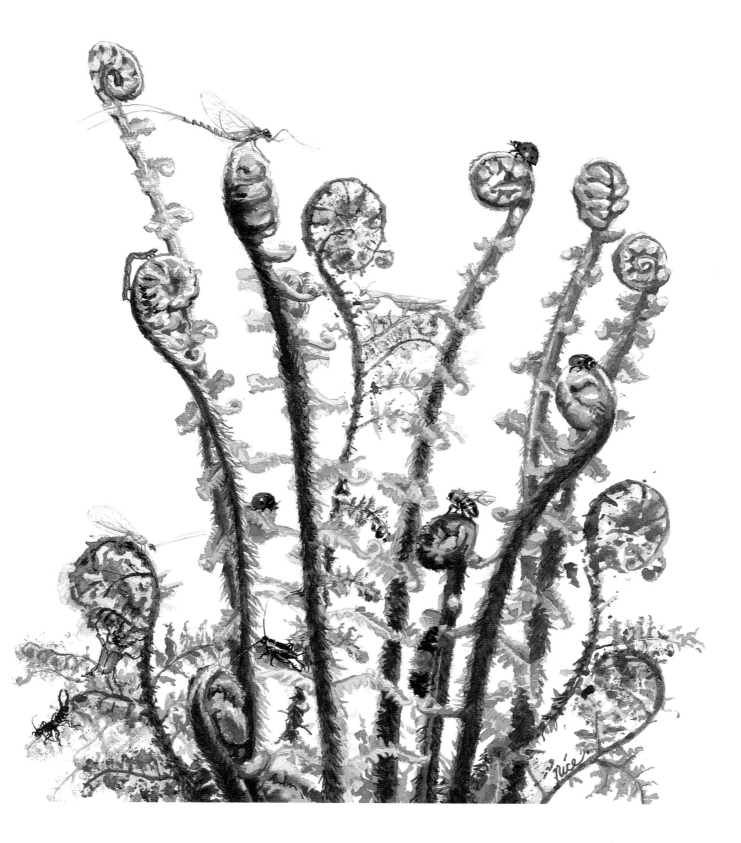

Pen Texturing Over Watercolor Wash

Ivy

A technique I've found useful, especially working in the field, is to sketch my design, then lay the color and shadow areas in quickly using flat or varied washes. The shapes and values are then further developed using glazes of watercolor or pen-and-ink over lays.

The shady courtyard painting seen on the opposite page was created in this manner. Loose, scribbly India ink work was used to detail the foliage and enhance its texture. The value of the shadowy archway was deepened using India ink. Sepia pen blending was used to subtly texture the roof and cobblestones. The lighter shapes and textures were brought into focus using a brush and glazing techniques.

The key to this technique is contrast. The various parts of the composition are not merely outlined in ink, by rote, but the pen is used with discrimination to enhance and develop selected parts of the painting to better catch the eye. What isn't inked is just as impor-tant as what is!

1. Lay down a green, varied wash. Shape the edges to resemble leaves, using the point of a round brush.

2. Use India ink and a .25 Rapidograph to draw in some rough leaf shapes.

3. Fill in the areas between the leaves with scribble strokes. These heavily inked places represent the thick, tangled interior of the ivy clump. The darker it is, the thicker the ivy will appear.

Ferns

Let the variance in the wash help determine the shape of the fronds.

This fern clump began as a ragged edged varied wash. Sepia ink was used to sketch in separate fern fronds once the wash was dry. Scribbling in the area behind the ferns added depth to the scene.

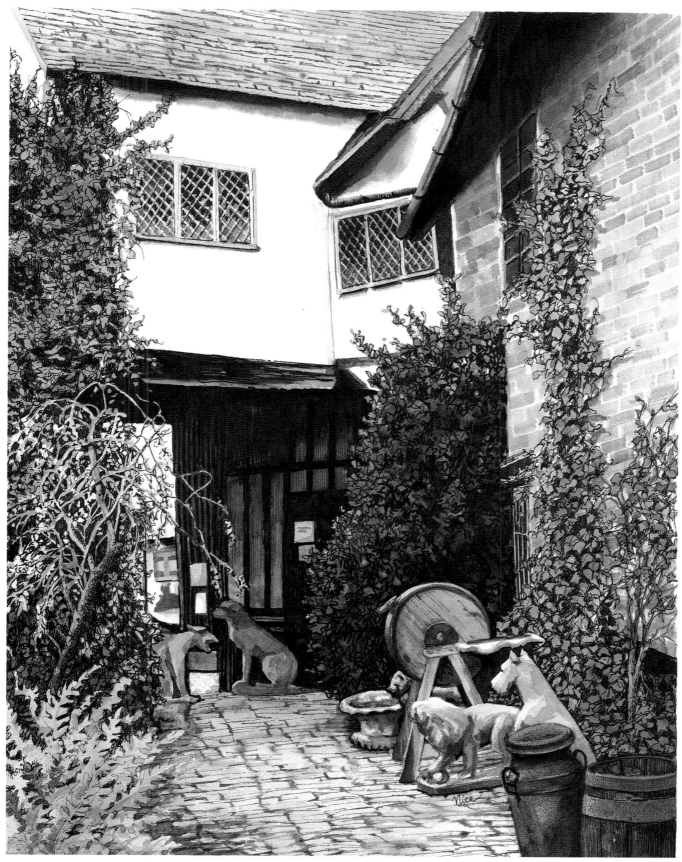

THE ANTIQUE DEALER'S COURTYARD
8" x 10" (20cm x 25cm) Watercolor wash overlaid with pen-and-ink texturing

Drawing a Bench in Perspective

We'll begin with a simple bench, facing straight forward.

① Start by drawing a rectangular box in one-point perspective. (All the extended lines running from the four corners of the box should meet at one vanishing point, which is located at the viewer's eye level.) If the bench is centered in regard to the way it is seen by the viewer, then the vanishing point is also centered.

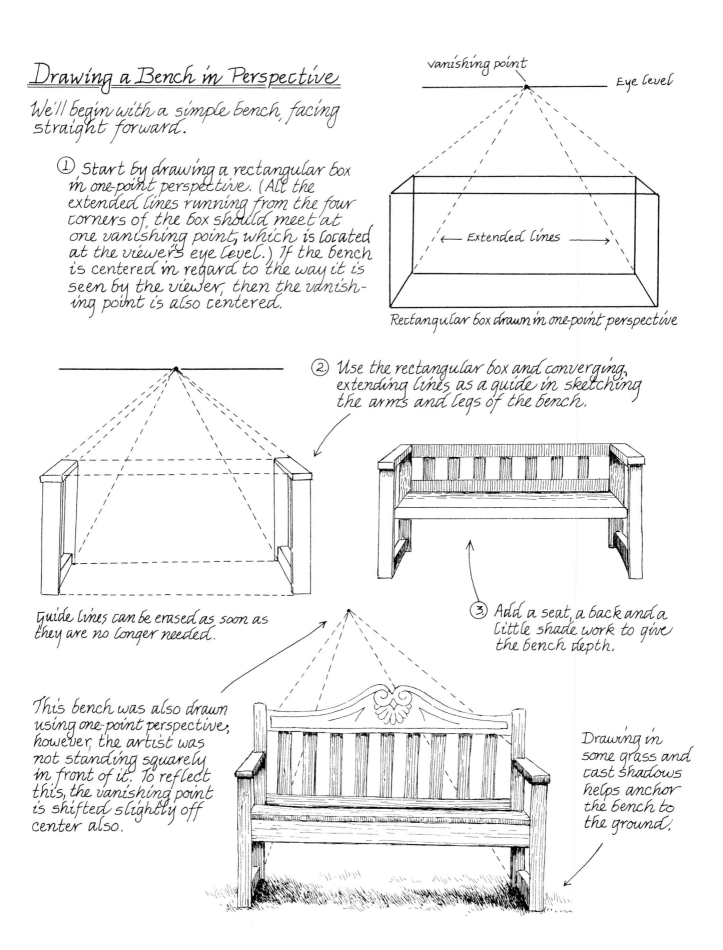

vanishing point

Eye level

← Extended lines →

Rectangular box drawn in one-point perspective

② Use the rectangular box and converging, extending lines as a guide in sketching the arms and legs of the bench.

Guide lines can be erased as soon as they are no longer needed.

③ Add a seat, a back and a little shade work to give the bench depth.

This bench was also drawn using one-point perspective; however, the artist was not standing squarely in front of it. To reflect this, the vanishing point is shifted slightly off center also.

Drawing in some grass and cast shadows helps anchor the bench to the ground.

When the bench is turned away from the viewer so that both the front and one side are visible, then two-point perspective comes into play.

Eye Level

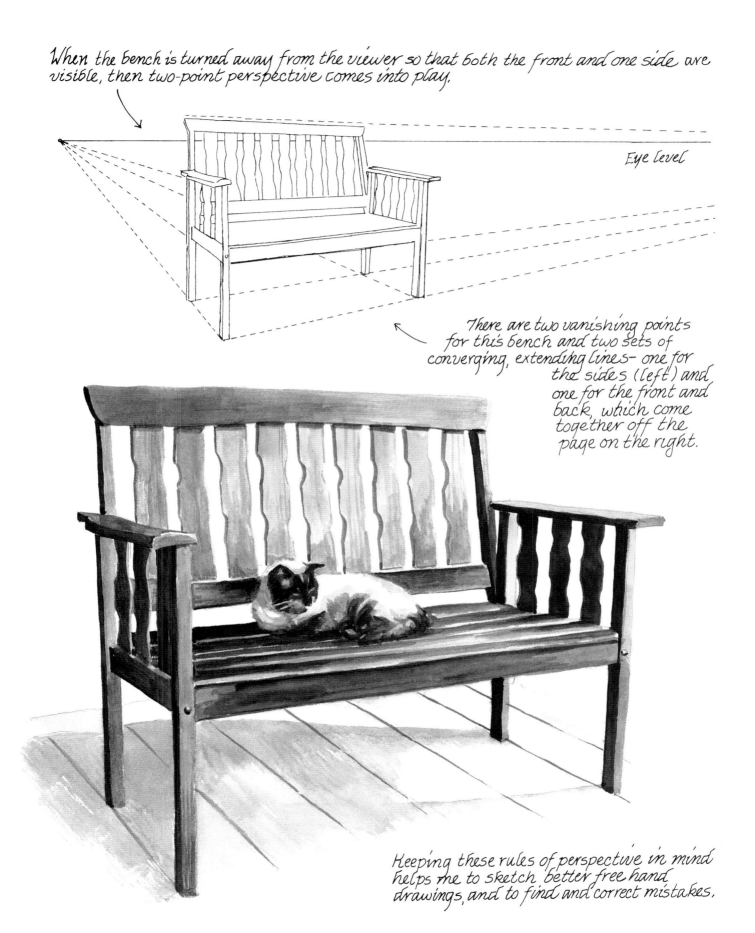

There are two vanishing points for this bench and two sets of converging, extending lines— one for the sides (left) and one for the front and back, which come together off the page on the right.

Keeping these rules of perspective in mind helps me to sketch better free hand drawings, and to find and correct mistakes.

Garden Chairs

Drawing a chair is very similar to drawing a bench. Chairs are just a lot less wide. Here are some of my favorite garden chair sketches.

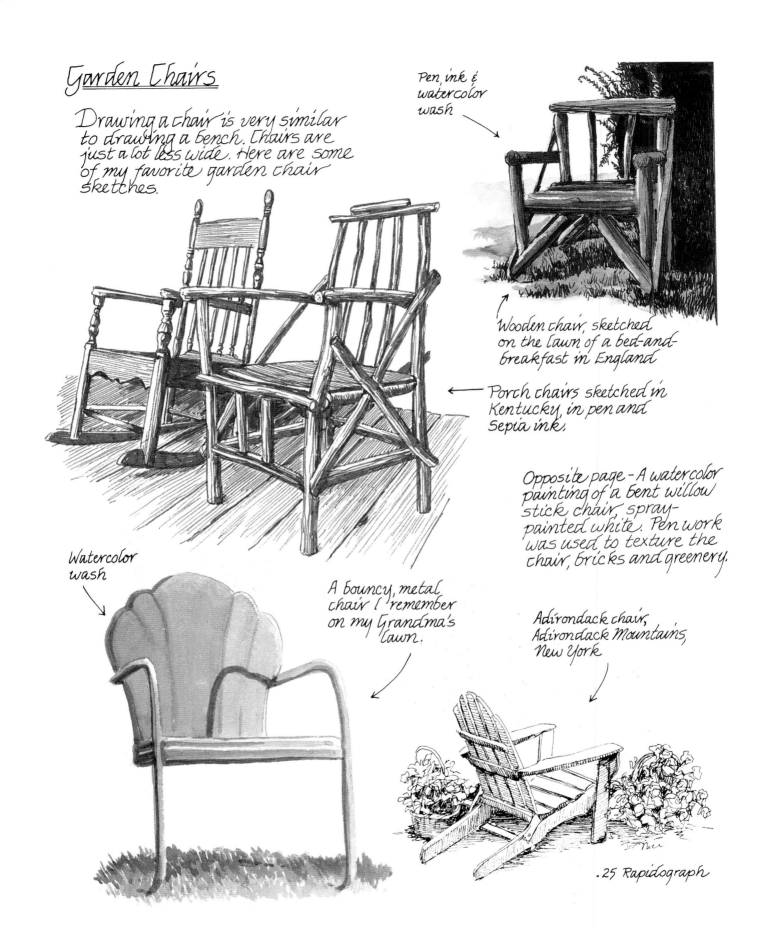

Pen, ink & watercolor wash

Wooden chair, sketched on the lawn of a bed-and-breakfast in England

Porch chairs sketched in Kentucky, in pen and sepia ink.

Opposite page - A watercolor painting of a bent willow stick chair, spray-painted white. Pen work was used to texture the chair, bricks and greenery.

Watercolor wash

A bouncy, metal chair I remember on my Grandma's lawn.

Adirondack chair, Adirondack Mountains, New York

.25 Rapidograph

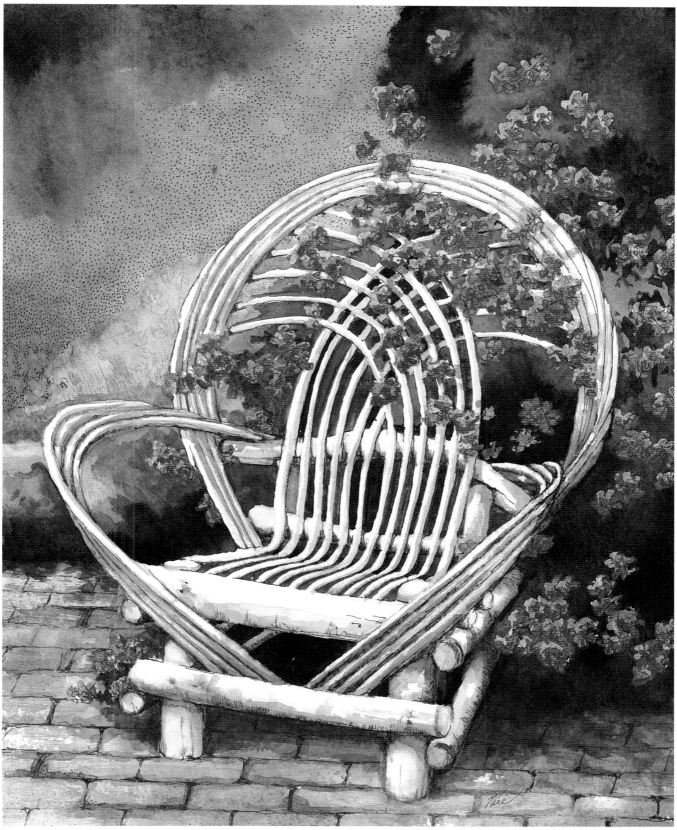

THE WHITE CHAIR
8" x 10" (20cm x 25cm) Watercolor with pen-and-ink detailing and texturing

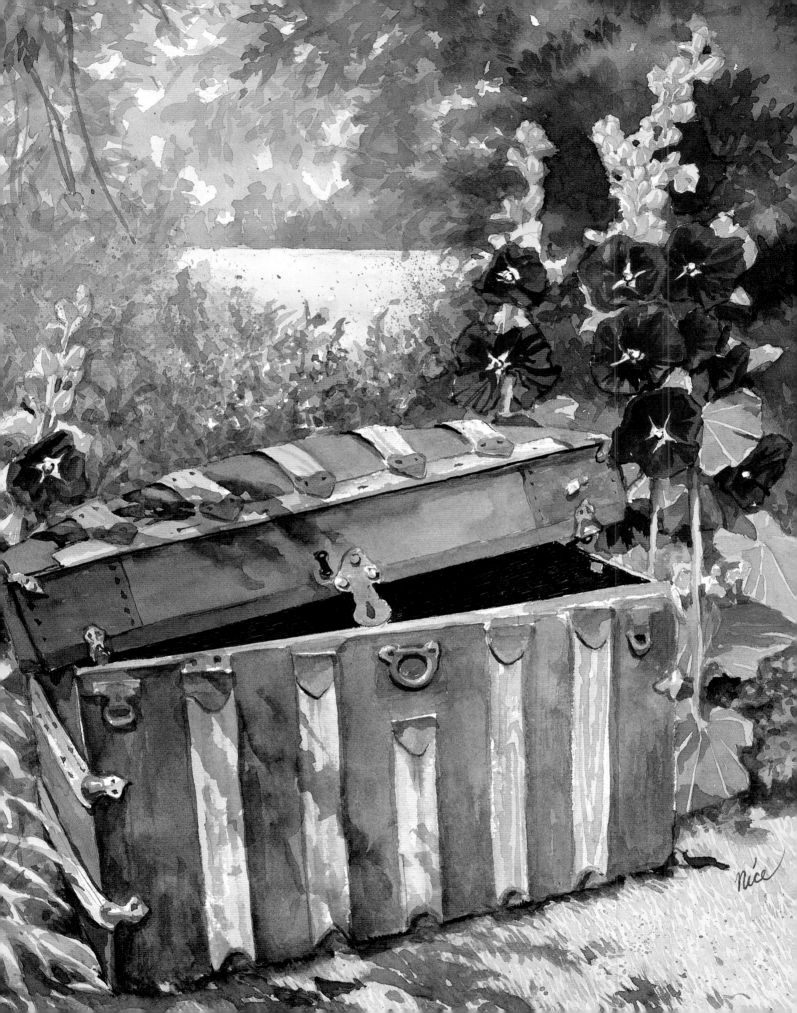

Antiques and Old-fashioned Perennials

Contrast adds vibrance to a scene. Consider how well red is contrasted by green, its complement. Now think of the warm hues of rusting metal. Its color range varies from the bright siennas of active rust to the mellow violet patina of aged metal. Set against the full range of garden greens, a wonderful, vibrant contrast is created. Better yet is the nostalgic contrast of old against new. It deepens the feeling of tradition and renewal passed on to the next generation.

In this chapter I will show you how to draw and paint some favorite garden relics. Step by step, the process of adding an aged patina to old metal will be revealed. Then we'll stroll together through some of my favorite garden scenes, where the past mingles with the present and Grandma's old-fashioned perennials are growing in abundance. Bring along your sketchbook. Feel free to sketch from these pages, borrow a few ideas to transfer to your own garden compositions or continue down the cobblestone pathways into the gardens found in your own imagination.

GRANDMA'S LEGACY
8" x 10" (20cm x 25cm) Watercolor enhanced with pen and ink.
Glazing was used to get the intense red in the hollyhocks and the crusty patina on the old trunk.

The Wheel

In the many gardens I have visited, I have found that wheels of various sorts are a continuous occurrence. I see wagon wheels, fly wheels, pulleys, cogs, grind stones, gears and old automobile tires tucked here and there amongst the flowers. There is something eternal about the circle that appeals to the perpetual nature and tenacity of the gardener.

As basic as the circle is, it can be a bit of a challenge to draw. Freehand circles usually turn out a bit lopsided. Tracing around the outside of a circular object works well if you can find one the right size. I usually build a frame work of pencil lines and then draw around them. ⟶

① ②

③

Lines must be of equal length with the midpoint of each line resting in the center.

④

If placed evenly, the guide lines can also be useful in sketching the spokes inside a wheel.

Antique car wheel ⟶

The narrow ends of an ellipse are rounded, not pointed.

Rear metal wheel from an antique farm tractor.

Unless a circle (or wheel) is viewed straight on, the eye will not see it as round in shape. Perspective enters in and makes it appear as an ellipse. The greater the viewing angle, the narrower the ellipse appears.

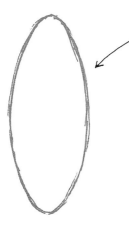

To check the accuracy of the curves of an ellipse sketched freehand, place it within a rectangle of the proper proportions. Divide the rectangle into fourths and diagonally from corner to corner. These visual guidelines will help you see and compare the curves more clearly. The curves in the opposite corners should be mirror images of each other.

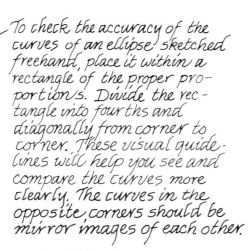

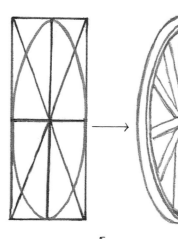

This ellipse is ready to be made into a sketch of a wheel.

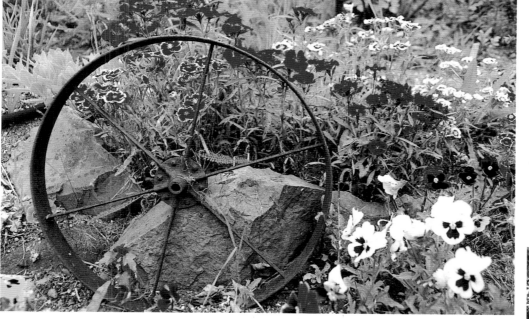

← Sweet Williams and pansies

Here are some wheels to practice drawing. The one above is from my own flower garden.

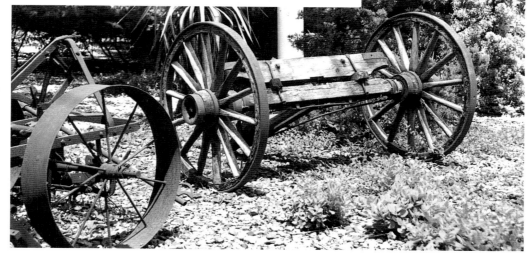

The old broken-down wagon wheel, seen in the painting on the opposite page, was rendered with great care and attention to detail. Pen blending was used to indicate the weathered wood grain. Ink stippling roughened the rocky soil and deepened the value of the background. It took several days to complete.

On the other side of the scale is the scribbly, quick sketch of the buggy wheel and "mum" garden seen below. It took twenty minutes to complete and was drawn with a Nexus roller ball pen. (Sepia ink).

This would make a nice journal entry or note card.

Loose scribble lines.

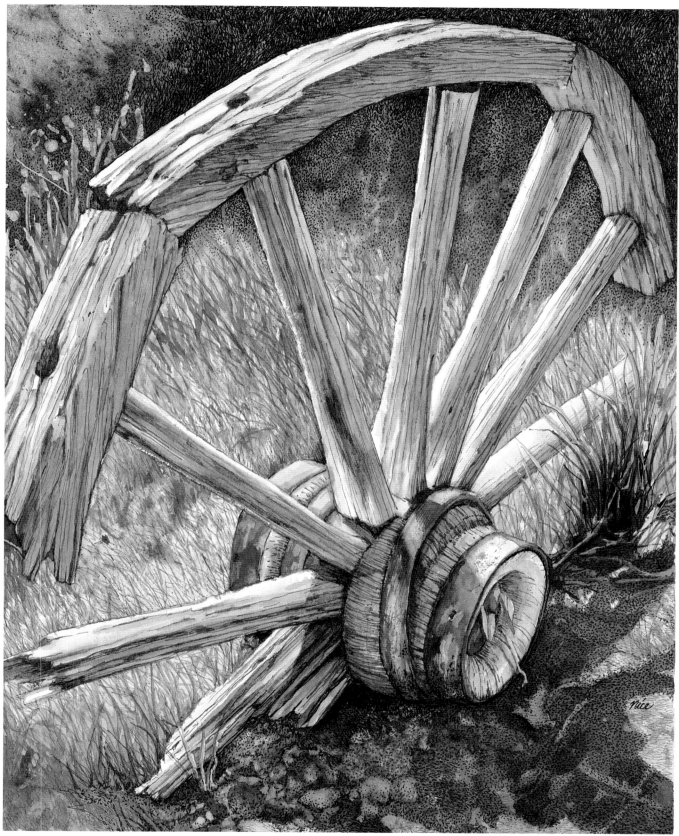

ALONG THE OREGON TRAIL
7" x 9" (18cm x 23cm) Pen and ink, watercolor wash

This wagon wheel study was painted in a style which is looser, brighter and bolder than my usual work. It's fun to experiment!

The wheel is laying in a bed of decorative crushed lava rock. The kitchen sponge would have worked well to depict this gravel, but I would have had to mask out the wheel... not in keeping with the quick, sketchy style I was using! So here's how I did it.

① Sketch in some rock shapes with a .25 pen. Keep them quick, loose and spontaneous.

② Daub some pale, muted maroon on half the pebbles.

(Cool red plus green)

③ Paint the rest of the rocks in cool grays.

④ Mix violet, sepia and Burnt Sienna to make a dark maroon, and paint between the rocks.

Darken the deep crevice shadows with India ink.

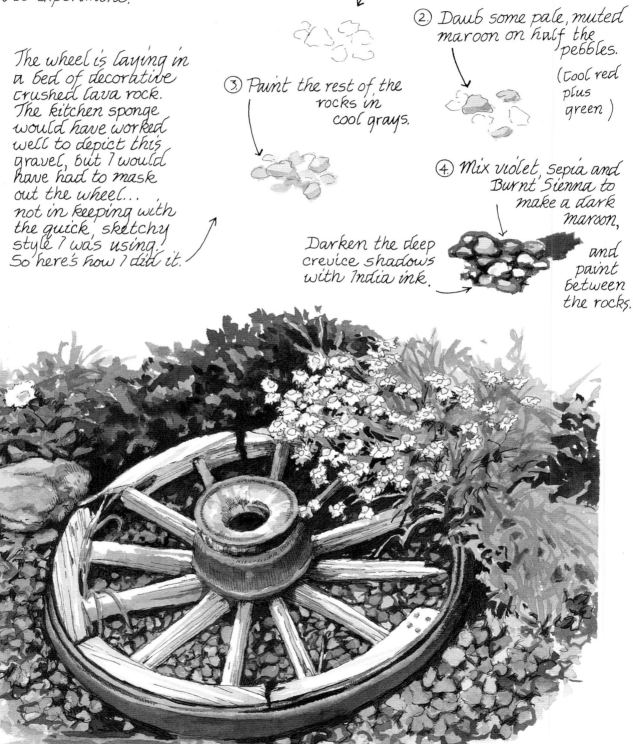

128

Old Wooden Wheelbarrows

Grandma used her wooden wheelbarrow to plant and tend her flower garden; now they have become part of the flower bed.

Pen-and-ink sketch tinted with watercolor

Cast tree shadows add interest to the bed of the wheelbarrow.

Notice how the heavy cast shadows help to define the edges of the wheelbarrow in this pen-and-ink study.

The Patina of Aged Metal

An effective way of duplicating the layer of crusty build-up and the subtle sheen that appears on old, aged metal objects is to lay down layers of heavy glazes of water-color and then lift them away in the "sheen" areas with a damp brush. This process is explained step by step on the opposite page.

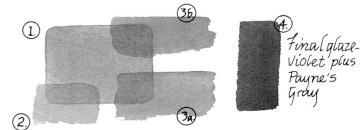

Final glaze - Violet plus Payne's Gray

These are the wash glazes used to paint the wheelbarrow below.

1. Burnt Sienna (base coat)
2. Orange
3a. Red muted with green, or ---
3b. Red violet muted with yellow green.

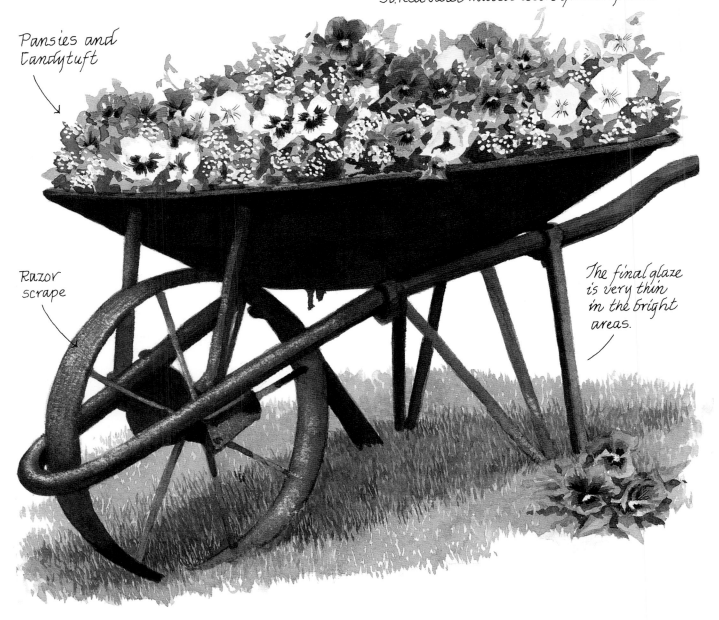

Pansies and Candytuft

Razor scrape

The final glaze is very thin in the bright areas.

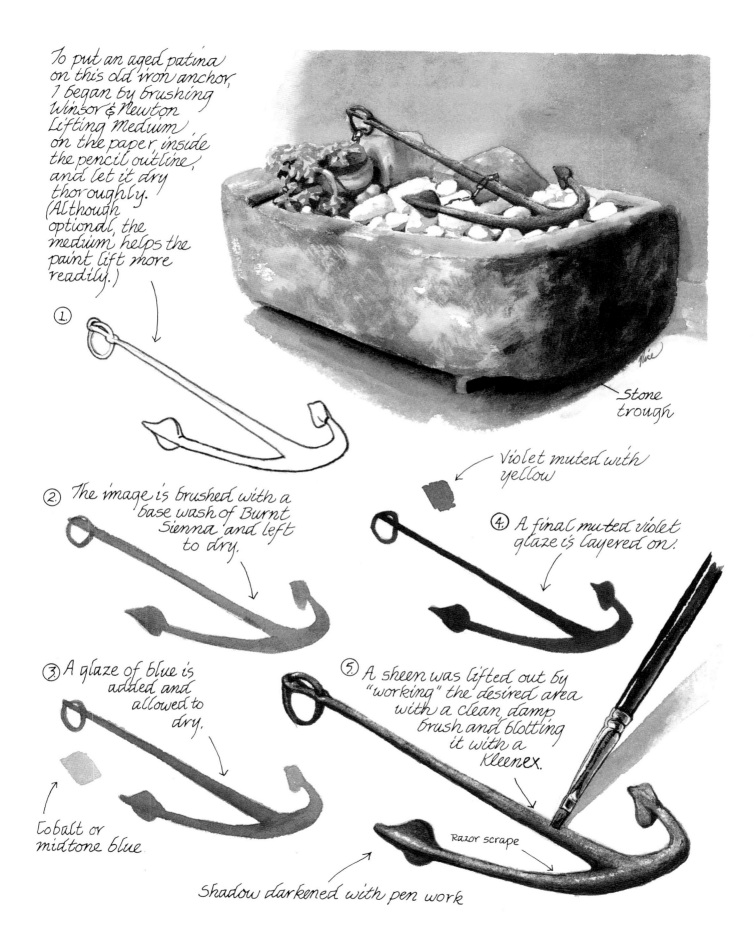

To put an aged patina on this old iron anchor, I began by brushing Winsor & Newton Lifting Medium on the paper inside the pencil outline, and let it dry thoroughly. (Although optional, the medium helps the paint lift more readily.)

①

Stone trough

② The image is brushed with a base wash of Burnt Sienna and left to dry.

Violet muted with yellow

④ A final muted violet glaze is layered on.

③ A glaze of blue is added and allowed to dry.

Cobalt or midtone blue

⑤ A sheen was lifted out by "working" the desired area with a clean damp brush and blotting it with a Kleenex.

Razor scrape

Shadow darkened with pen work

Old Fashioned Garden

Come stroll with me through gardens simple,
 of sprawling nature, yet sublime,
 where gathered seed, from wrinkled hand,
 springs forth and blooms in summertime.

Pause and smell the ancient fragrance,
 wafting from an era past.
 From primal roots, the vines are striving,
 climbing pickets, clinging fast.

Here things grow in random order,
 spread the flowers where they will.
 Quiet, hear the old ones whisper,
 echoed in each songbird's trill.

Nostalgia treads the foot-worn cobbles,
 embedded deep by passing year.
 Come push the stones a little deeper,
 Slow your step and linger here.

 Nice

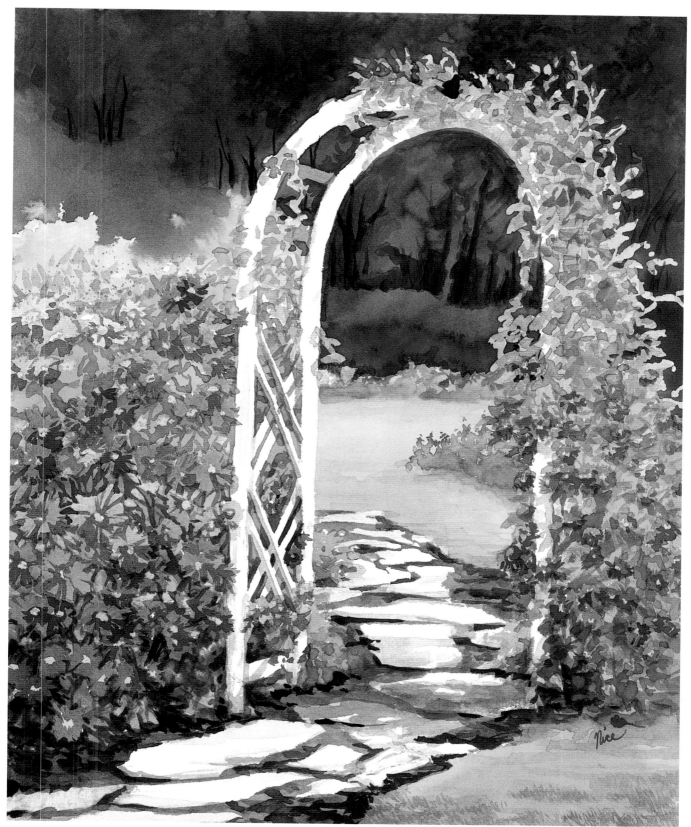

INTO AN OLD-FASHIONED GARDEN
8" x 10" (20cm x 25cm) Watercolor.
Masking fluid was used to protect the asters, vines, stones and the trellis.

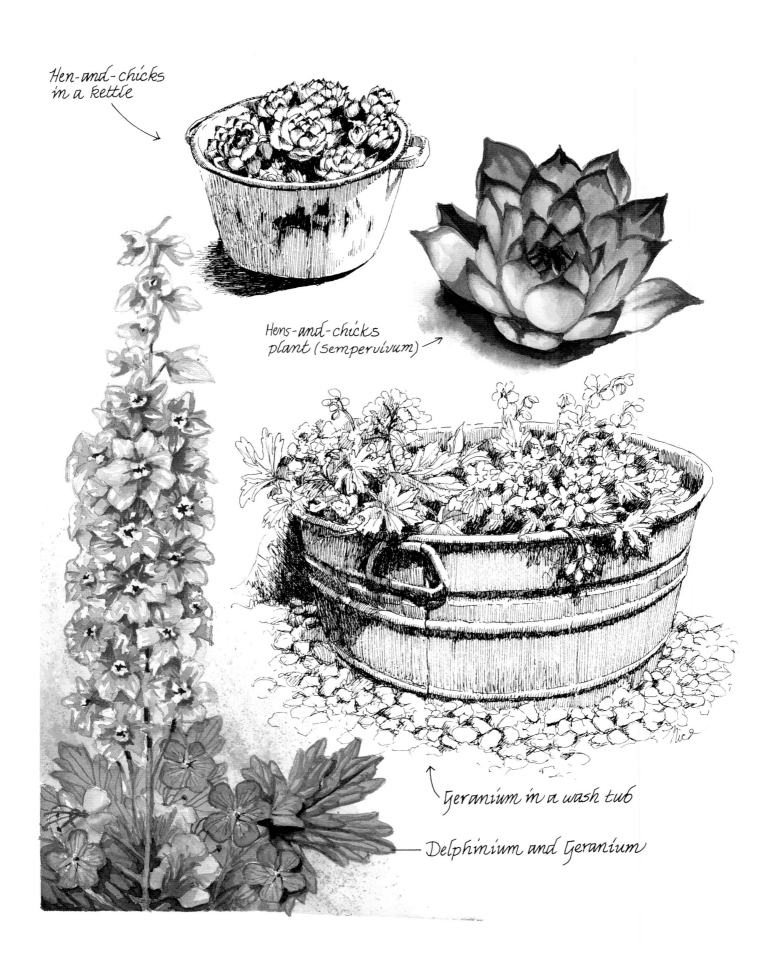

Hen-and-chicks
in a kettle

Hens-and-chicks
plant (sempervivum)

Geranium in a wash tub

Delphinium and Geranium

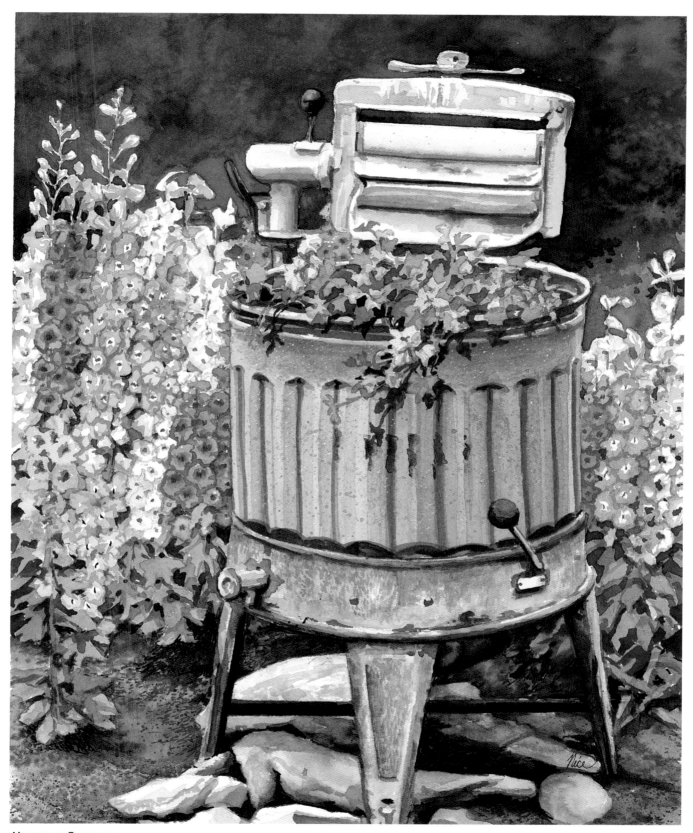

A'WASH IN FLOWERS
8" x 10" (20cm x 25cm) Watercolor.
The background flowers are delphinium; the flowers in the wringer washtub are cranesbill geraniums.

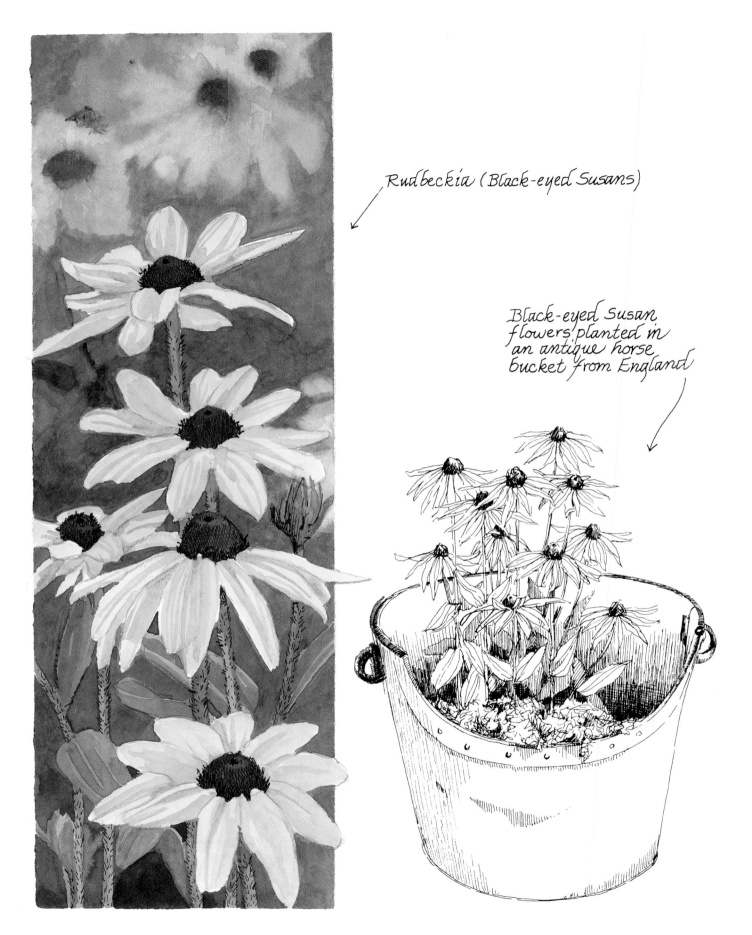

Rudbeckia (Black-eyed Susans)

Black-eyed Susan
flowers planted in
an antique horse
bucket from England

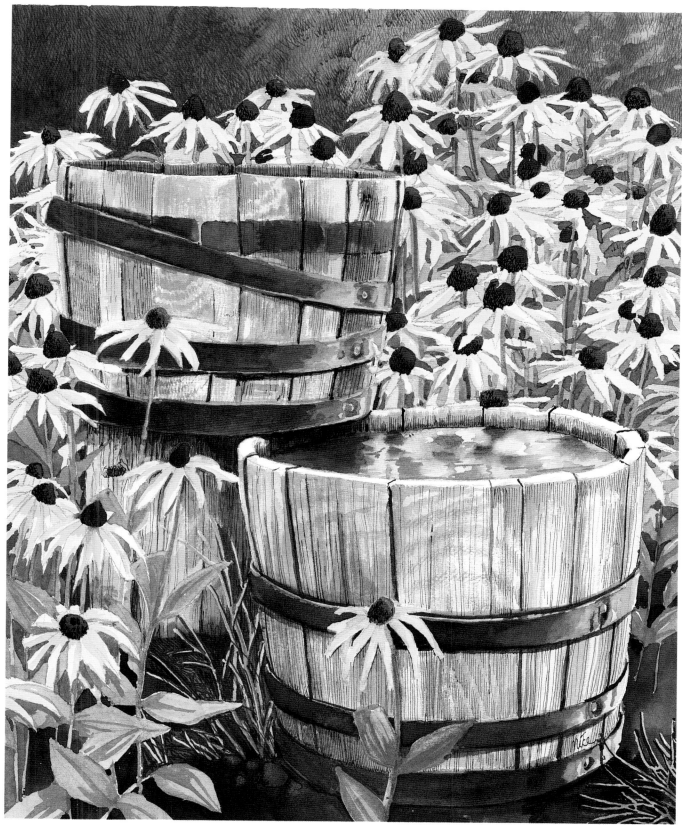

REFLECTIONS IN A WHISKEY BARREL
8" x 10" (20cm x 25cm) Watercolor enhanced with pen and colored ink.
The flowers are black-eyed Susans.

Daylily (Hemerocallis)

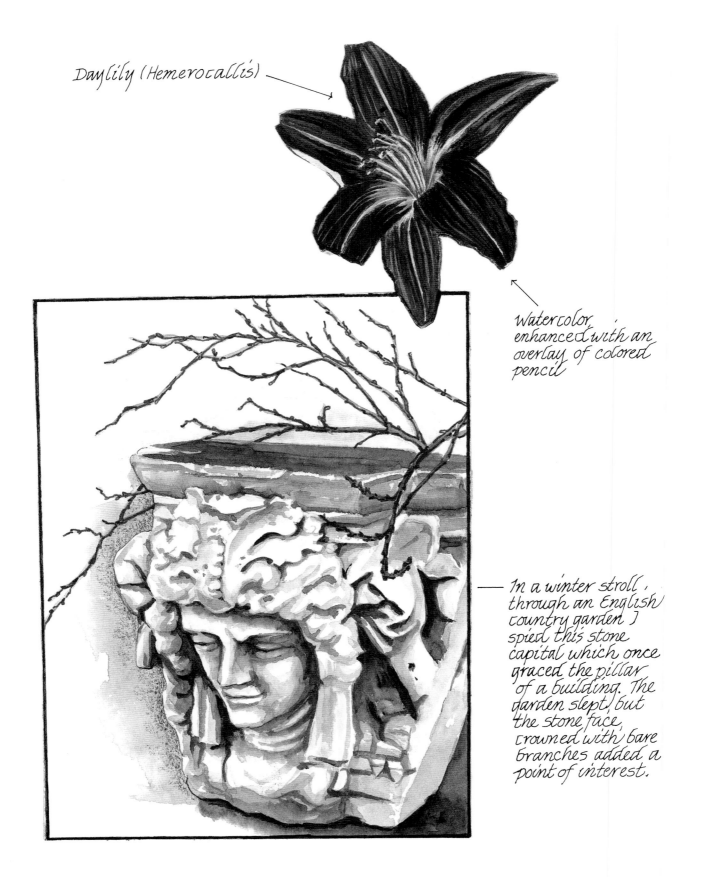

Watercolor, enhanced with an overlay of colored pencil

In a winter stroll, through an English country garden I spied this stone capital which once graced the pillar of a building. The garden slept, but the stone face, crowned with bare branches added a point of interest.

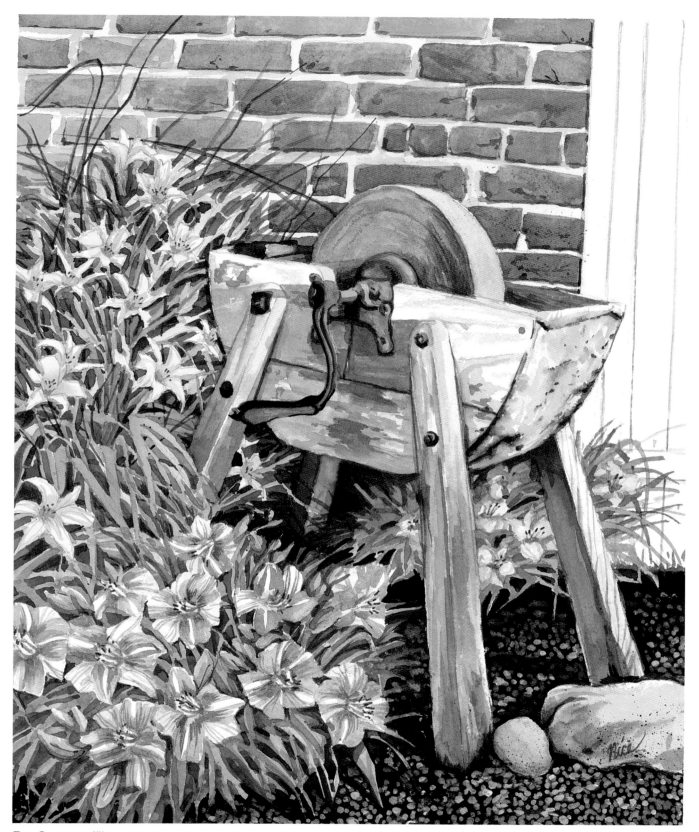

THE GRINDING WHEEL

8" x 10" (20cm x 25cm) Watercolor.
Masking fluid was used to mask out the daylilies and to create the pebble effect in the foreground.

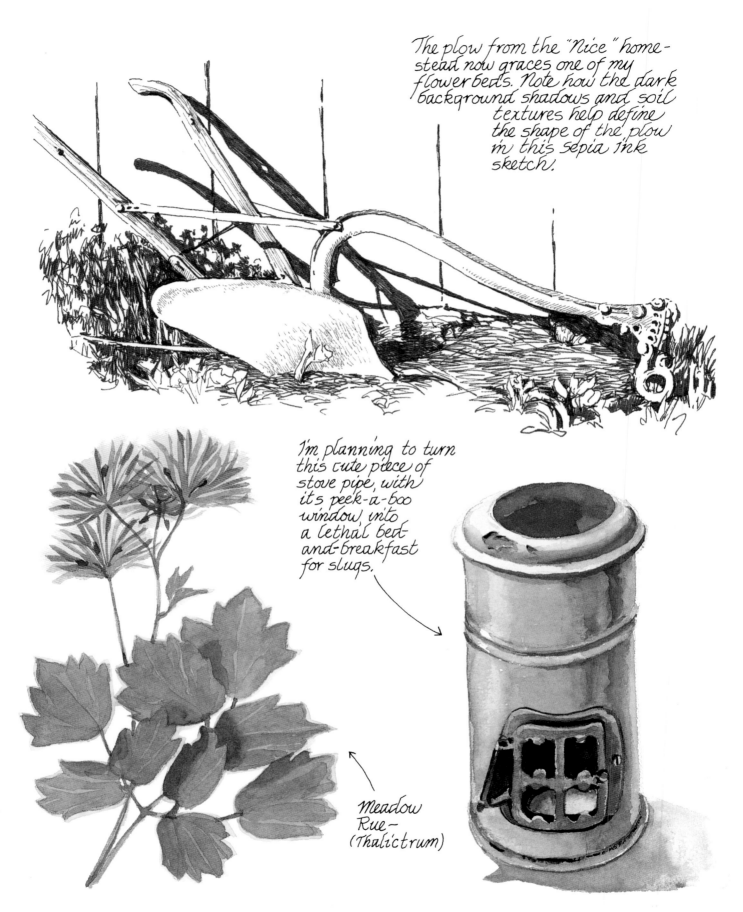

The plow from the "Nice" homestead now graces one of my flowerbeds. Note how the dark background shadows and soil textures help define the shape of the plow in this sepia ink sketch.

I'm planning to turn this cute piece of stove pipe, with its peek-a-boo window, into a lethal bed-and-breakfast for slugs.

Meadow Rue— (Thalictrum)

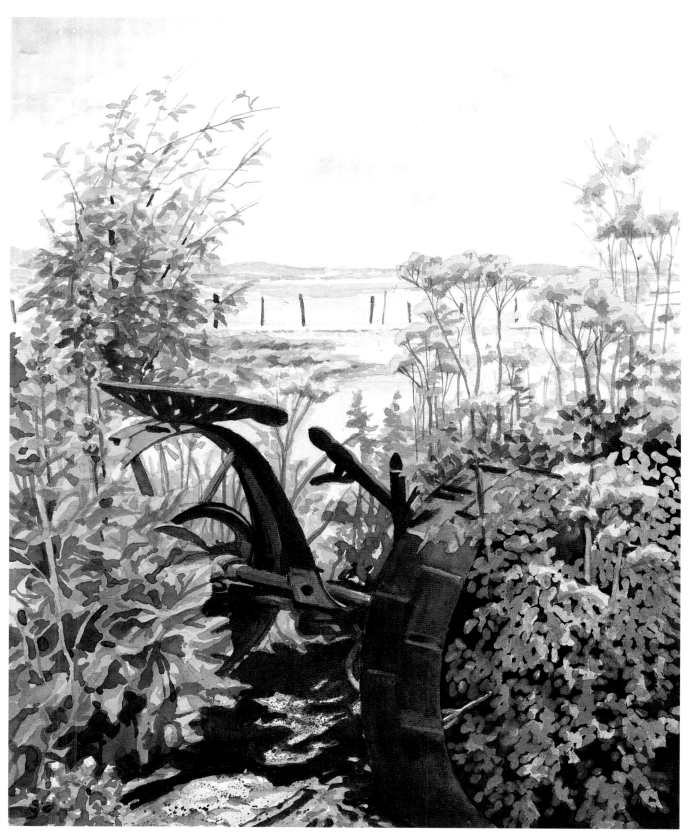

ANTIQUE TRACTOR AND MEADOW RUE
8" x 10" (20cm x 25cm) Watercolor

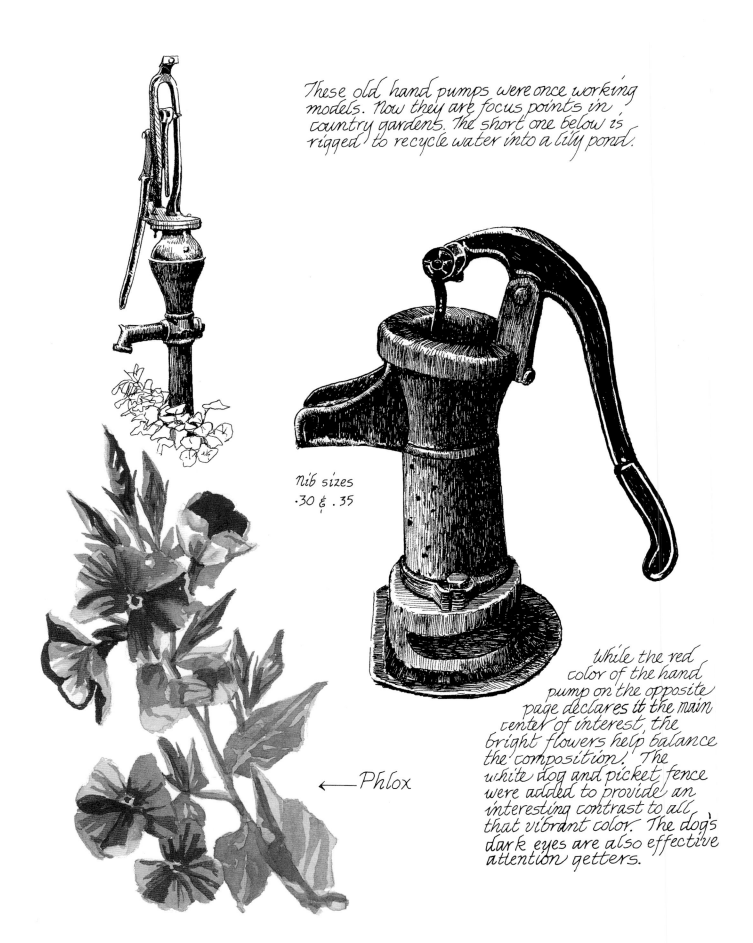

These old hand pumps were once working models. Now they are focus points in country gardens. The short one below is rigged to recycle water into a lily pond.

Nib sizes
.30 & .35

← Phlox

While the red color of the hand pump on the opposite page declares it the main center of interest, the bright flowers help balance the composition. The white dog and picket fence were added to provide an interesting contrast to all that vibrant color. The dog's dark eyes are also effective attention getters.

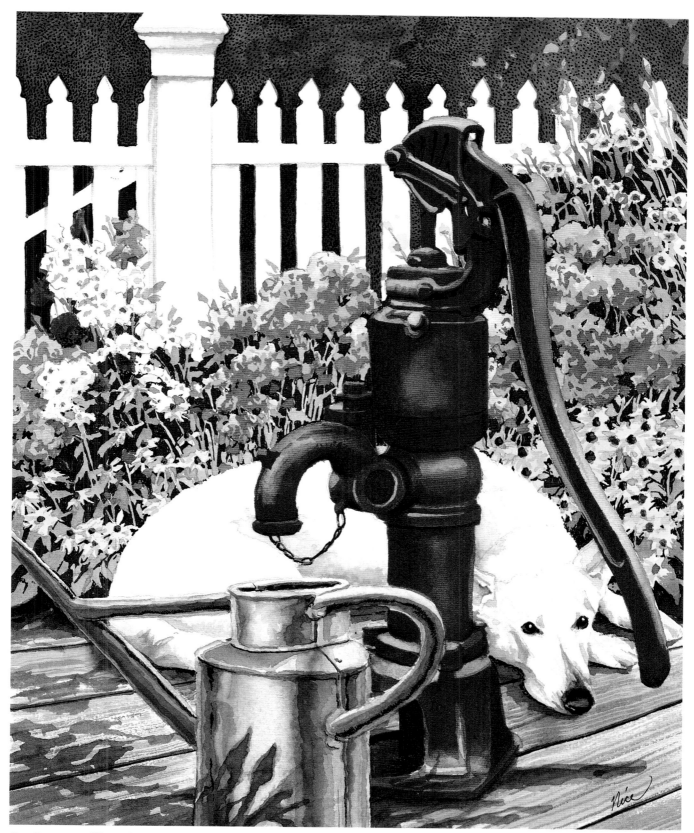

Red Pump and White Dog
8" x 10" (20cm x 25cm) Pen and ink, watercolor.
The perennial garden consists of phlox, coreopsis, black-eyed Susans, rose campion and red dahlias.

Index